SECRETS TO
DRAWING
HEADS

Allan Kraayvanger

Sterling Publishing Co., Inc.
New York

This book is dedicated to you.

If you get half as much out of reading it as I did writing it, we are both richer for the experience.

Library of Congress Cataloging-in-Publication Data Available

10 9 8 7 6 5 4 3 2

Published by Sterling Publishing Co., Inc.
387 Park Avenue South, New York, NY 10016
© 2005 by Allan Kraayvanger
Distributed in Canada by Sterling Publishing
c/o Canadian Manda Group, 165 Dufferin Street
Toronto, Ontario, Canada M6K 3H6
Distributed in Great Britain by Chrysalis Books Group PLC
The Chrysalis Building, Bramley Road, London, W1O 6SP, England
Distributed in Australia by Capricorn Link (Australia) Pty. Ltd.
P.O. Box 704, Windson, NSW 2756, Australia
Printed in China
Sterling ISBN-13 : 978-1-4027-2064-2
 ISBN-10 : 1-4027-2064-5

For information about custom editions, special sales, premium and
corporate purchases, please contact Sterling Special Sales
Department at 800-805-5489 or specialsales@sterlingpub.com

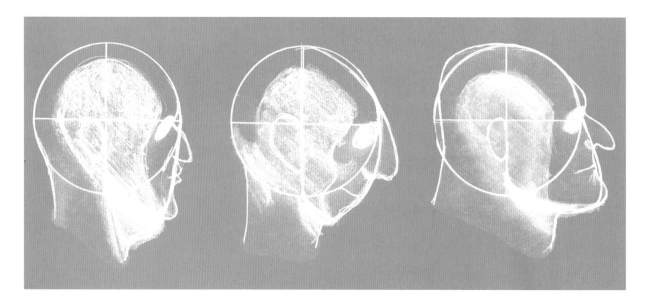

CONTENTS

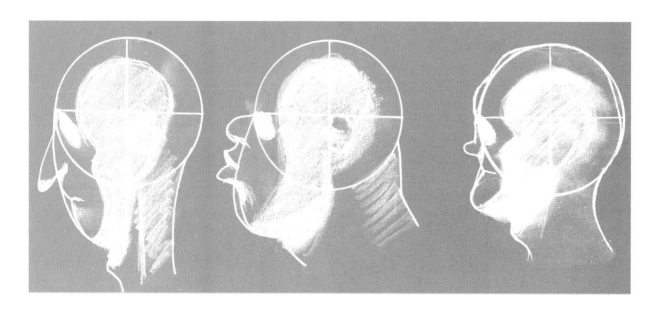

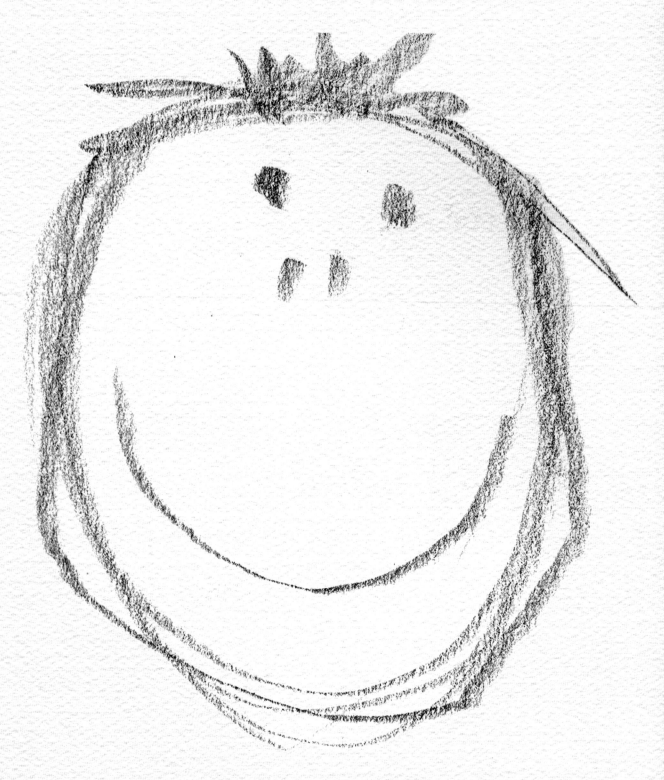

This is very likely the way you drew your first face. You started out
with an oval and placed two spots at the top for eyes. Then you
put a wide slash near the bottom for a mouth, added a couple of
dots for a nose, and finally some wire for hair.

This book is how you get from that...

...to this.

INTRODUCTION

Can you imagine Michelangelo as a child beaming proudly when he picked up his first piece of chalk or charcoal and drew a crude, simple oval with dots for eyes and a wide crescent across the bottom for a mouth? That's very likely what he did, along with practically every other artist since the dawn of art. Of course we don't know with absolute certainty that they all began that way, but it is remarkable how similarly children all over the world draw when they first get their hands on something to draw with.

We have a strong tendency to draw things symbolically, rather than the way they actually look, and this is the big reason most of us have problems drawing a head. Although there is great charm in some of these untutored drawings, if we want our drawings of people to be convincing, we need to learn to draw them the way they actually look.

The head is the first thing anyone looks at if there is a figure in a painting or drawing, and a badly drawn one will ruin a piece of art no matter how good the rest of it is. The head seems difficult to draw because we think it is. It's a self-fulfilling prophecy: We expect to have trouble, and we do.

The drawing on the facing page contains the big secret to learning to draw heads and faces. There is far more to it than first meets the eye. Most people could learn to draw this face with very little study. That is exactly what I want you to do now, before you read any farther. You can draw it smaller if you want, and a simple oval outline will do. Just do the best you can to draw it as accurately as possible. Then read on. I think you're in for a few pleasant surprises, especially if you've been struggling with the complexities of the head for any length of time.

With a little basic understanding, and a lot of pleasant drawing, I will show you that heads are no harder to draw than anything else, and a lot more fulfilling.

Let's take a look at a brand-new way of learning to draw the head.

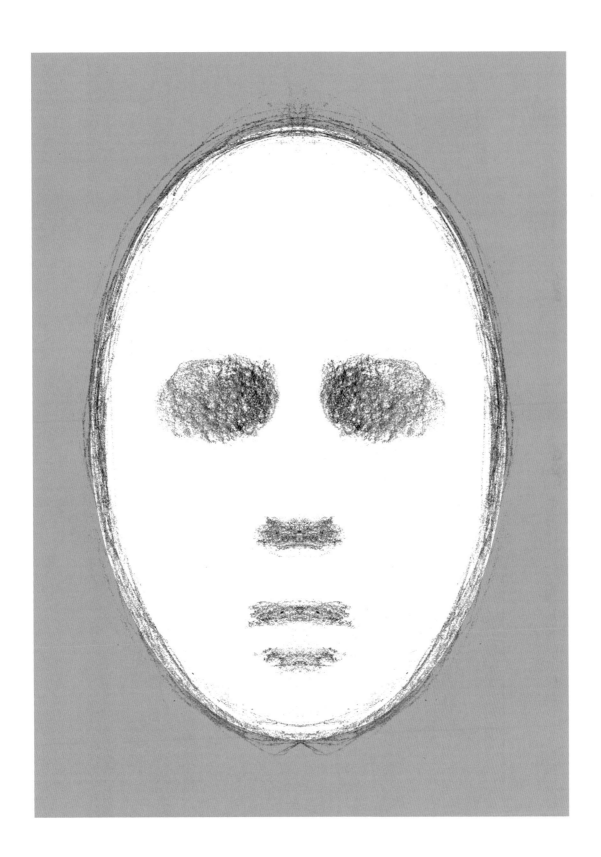

CHAPTER ONE
THE BASICS

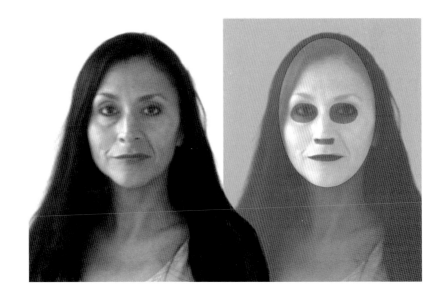

The key to understanding the complexities of the head and face is to reduce it to its simplest structural form.

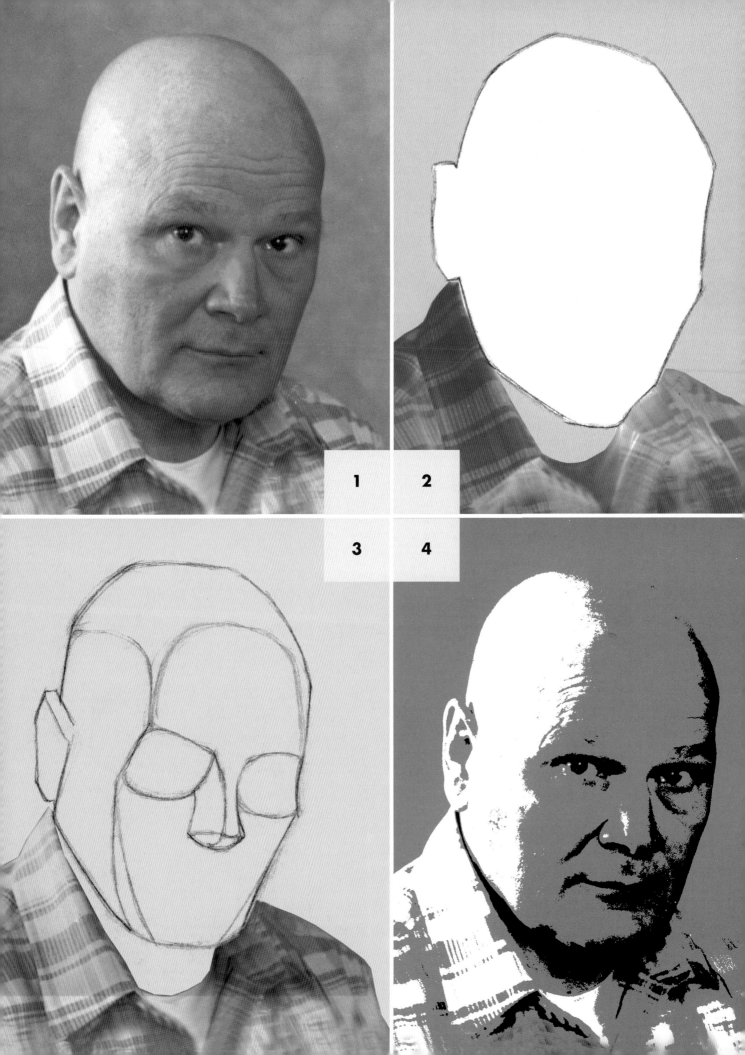

1 2

3 4

SHAPES, PLANES, FORMS, AND VALUES

1 It seems like a good idea to begin our study by getting acquainted. That's why I chose this photograph (yes, it's me) to help clarify a few of the terms that I'll be using regularly throughout this book. I also wanted a fairly average specimen with no special features that could throw us off as we study the so-called average proportions of the head.

Except for being slightly blockier than average, and shaved—which is what we want at this point anyway—this head has no outstanding characteristics that would make it an easy portrait, so it will be ideal for our first serious attempt at working from a photograph a couple of chapters down the road as well. You can also use this picture to check the things I will say next about proportions.

2 I will often speak of the *shape* or *shapes* in these pages. When I do, I'm referring to a thing in silhouette—its two dimensional, or flat, aspect. When I speak of it in its three-dimensional, or solid, aspect, I use the word *form* or *volume*. The white area in picture 2 on the left is the "shape" of the head. Picture 1 shows both the volume and the shape; picture 2, the shape. In this picture, the shape is modified: I straightened segments of the contour where it was possible to do so before it turned too much, in order to show you how curves can be drawn with straighter lines to help you see them more accurately as you draw. You can always modify them later to soften them.

3 This gruesome illustration shows the *planes*. This process involves flattening of curves that I did in drawing 2, but we're now flattening the curves around the whole form. This is what I mean when I use the term *planes*. I want you to take special notice where the side planes of the head meet the front planes. Try to see them in the photo, picture 1. This is an important structural consideration, as you will see shortly.

4 This picture has been mechanically reduced to three flat values: a white, a black, and a middle gray. It clearly shows both a side plane and a front plane. Note how the darks display the details. Things are darkest where the least light can get to them, such as the deep crevices or areas beneath light-blocking obstructions. They are also sometimes actually darker, as with the irises of the eyes, eyelashes, and brows in this case, or the hair in some other examples. If you have trouble finishing up the drawing we will be doing later, come back to this picture to study the shapes of these dark areas.

STARTING RIGHT

Start out right by keeping loose right from the beginning. If you can do that, you can avoid the tight, cramped little drawings that usually result when a beginner starts out with an instrument (such as a pencil or pen) that makes a fine line. When you relax and let it happen, however, your hand really will do exactly what your mind tells it to do. You can turn these study sessions into a time of enjoyment and pleasure, or into a tense struggle to be perfect every time you make a line. Let's enjoy it. You'll learn faster that way. Those of you with more experience might get more from this if you imagine yourself a rank beginner, and go at least through this first section with a wide-open mind—as though you've never drawn before.

The list of materials you'll need to start out with is simplicity itself. If you can find an art supply store nearby, buy a few sticks of conté crayon, like the one pictured in the inset on the facing page. They can be black or a shade of brown. Sometimes the bigger craft stores carry them also. These are the ideal drawing tools to start with, but if they're not available, you can use regular crayons; the darker colors, preferably black, will work just as well. Charcoal also comes in sticks that look just like the one pictured. It's a good substitute, but it is a bit messy, and it tends to smear easily as you work. Anything that is soft, blunt, and makes a good, strong mark is workable at this point, so don't rush out and spend a fortune on materials until you get enough experience to know what you want. By the time you get to chapter 3, you might want to begin using a thick, soft-leaded pencil, like the Ebony pencils you find in art supply or craft stores, but that will be up to you.

For now, almost any paper that you can mark on will be workable. The cheaper it is, the less you'll worry about wasting it. A pack of 8½-by-11-inch of unlined bond that you can get in the stationery section of almost any mass merchandising store will work just fine. Most of the drawings in this book were done on white computer printing paper of that size. Later, when you feel the need, you can upgrade your material selection however you want. For now, though, let's keep it simple and inexpensive so you can throw away a few thousand drawings without going broke.

Before going one step farther, I want you to draw a simple oval the shape of a head, then quickly draw a face in it. Keep it simple, and save it for later. This will be your guide to your progress as we move on.

This illustration is big for a reason. At this point, it's important that you grip your crayon loosely and from above, as shown. With this grip you can lay it flatter for broad strokes, or angle it to give you a thinner line, but you won't have the tendency to tighten up, which would give you the fussy, picky results of holding your tool as if for writing. This grip is a bit awkward at first, but it gets very comfortable quickly, and it makes a big difference in your results. Don't give up before you give it an honest try.

THE BASIC MAP

If you drew that simple head map on page 7, you no doubt found it considerably easier than drawing a detailed head. Well, guess what? Drawing any head over this simple map is no harder. Just make sure the basic map is light enough to work over. The secret is to learn the basic proportions, and then learn to draw this map in any position. That's what you're going to learn to do in this chapter. Now, I never said this was going to be easy, but it is a whole lot easier this way any other way I know of. And it's fun as well.

Let's get something clear right at the beginning: I am not offering you any formulas for drawing in this book. I'm simply taking the struggle out of learning. The only real way to draw is to learn to see; to relate the big, simple shapes and draw them exactly the way you want them. You also need to turn these shapes into believable rounded forms. This takes a great deal of drawing and study to learn. This method takes you right to the heart of things, into the structure, where the whole essence of drawing anything lies. The little details take their rightful place at the bottom of your priorities instead of cluttering up your vision before the foundation is in place.

The diagrams here are meant to teach you to think; to give you a concept of the basic head shapes, forms, and proportions; and to give you a takeoff point to build from logically. Ultimately you will look for the actual shape patterns in each head, and get them in right from the start. But you need to know what to look for, and how to draw solidly without unwanted distortion. And best of all, you can work on learning this without a model.

The little details—eyes, noses, mouths—are relatively unimportant in a well-drawn head. The big structure and positioning of these details is everything, as I will demonstrate later.

A basic head map that is roughly an average of all heads will serve as our model to work from. I know that it's not perfectly accurate, but it's the best compromise I can come up with that can still be easily learned and drawn freehand by eye alone. It is simply this:

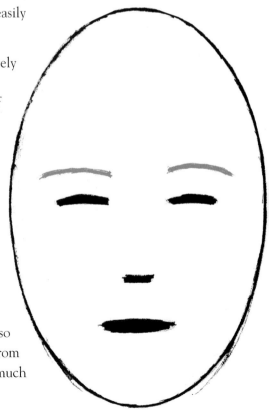

- Viewed from the front, the head is a rough oval approximately one and a half times as long as it is wide.
- The eye line is halfway between the top and the bottom of the oval.
- The eyebrows are situated slightly above the eyes (see the drawing on this page).
- The bottom of the nose is located halfway between the eyebrows and the bottom of the chin.
- The mouth is located slightly above halfway between the nose and the chin.

If you were to divide the oval into five spaces, an eye would be one space; each of the spaces between and on either side would take up one space as well.

Learn to draw this map by eye. Eventually you will know it so well that you'll instantly recognize how individual faces deviate from this norm. Drawing their individual proportions will then come much easier for you.

THE SKULL

The influence of the skull is visible under every head if you look for it. The basic structure of each head is determined by the structure and proportions of the underlying skull. All the muscles and other tissue that overlie it have their effect, but it's the skull itself that determines the big picture.

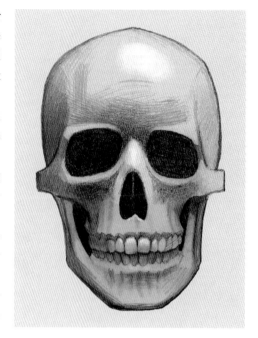

Just as with the face, each individual skull is different from all others, and yet there is a basic commonality that carries over from one to the other. This makes it easier to learn and apply as you draw.

Our face map can be easily turned into a skull shape for drawing into, and herein lies the big secret to our method for learning to draw the head.

Simply put two big sockets where the eyes would fit, and maybe smudge a couple of light tones under each cheek. Your basic map now captures the sense of the underlying skull structure.

Learning to draw this map, is much easier than trying to draw from real heads with all their complex details. If you take the time now to learn to draw this simple structure in every conceivable position, you will develop the ability to sense its solidity and put any face or head you can imagine or see onto it. The big mystery of drawing heads will vanish into thin air. But one word of caution. This is not a gimmick or trick for drawing heads. It's a simple learning device, one simple step in the process of learning to draw, and as soon as you get this material into your subconscious, you must reach out and expand your thinking to avoid falling into a stylized approach. Each head has unique shapes that deviate slightly from this model, and you must learn to see and draw these modifications.

In the long run, nothing can replace actually drawing from a living model.

FINISHING THE BASIC HEAD MAP

Let's put the finishing touches on our face map, and then get down to some serious drawing.

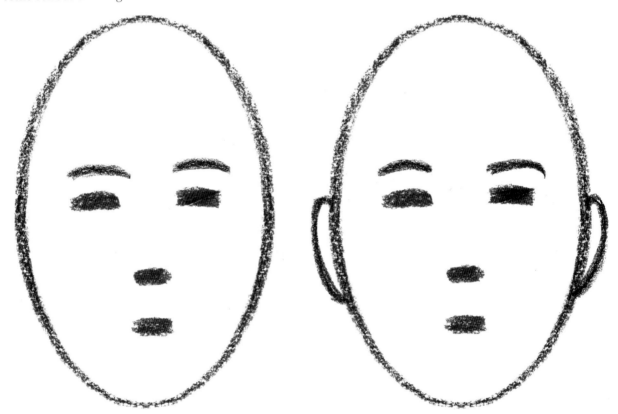

Eyebrows

The eyebrows obviously go above the eyes. But their position is fairly critical. Experiment a little by putting them in higher up, or down closer to the eyes. Now pull them closer together or farther apart. It's surprising how these simple adjustments can affect a face. The drawing above has them at a fairly neutral, average position—a good place to start.

Ears

The ears come next. They are usually lined up with the eyes and the mouth. Of course there are exceptions out there: Some ears stick out, and some lie flat against the head. Some are tiny, others gigantic, but this is again, an average placement and size for the ears.

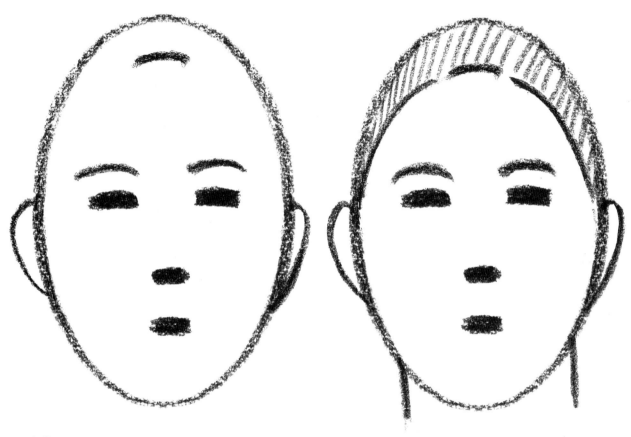

Hairline

Now we get to the hairline. On the average head, it will start approximately one-quarter of the way down from the top of the head to the eyebrows. Place a mark at that point. Then draw a line down from both sides of your mark to the top of the ears. Draw it curved, as though it lies on a rounded surface such as an egg. You can shade in the area above the line if you like.

Neck

To complete our map, we will put in two lines to represent the neck. If we were drawing a female, we would keep the neck pretty slim, and slightly longer. On a male the neck can be much wider—as wide as the head in rare cases.

This is our complete map for the placement of features in an average head. Again, real heads vary wildly from each other, and from our model. It's your job to learn to recognize these deviations and to capture them, or even accentuate them.

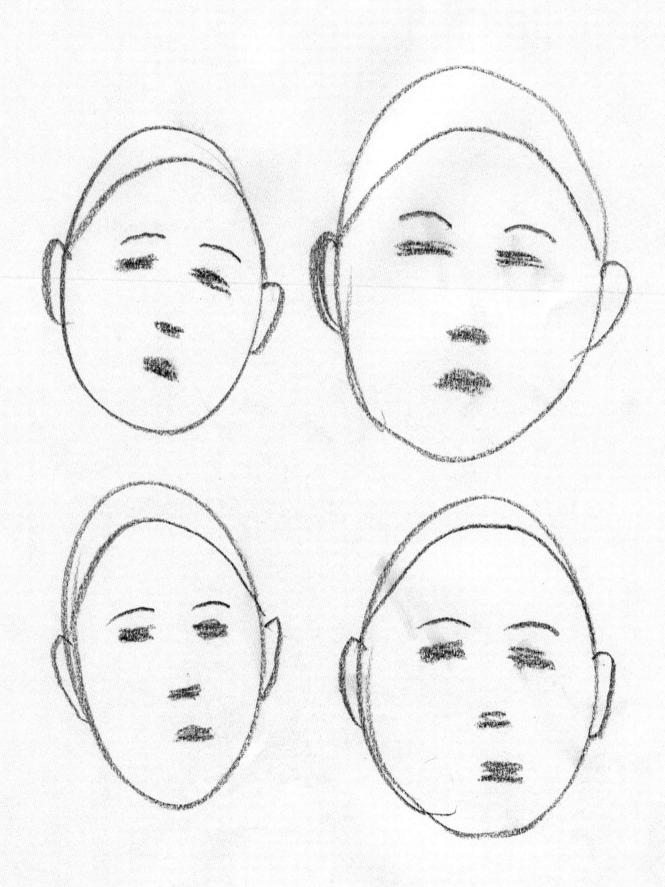

START DRAWING

Now let's start drawing. That's the whole reason you bought this book, right? Well, this is the time to start, and you won't stop until you've thrown out a couple hundred drawings.

You really are going to need to make hundreds of drawings on your way to perfection—and you still won't be there, so you might just as well get started. At least you'll have fun trying.

Seriously, you should now make dozens of free-flowing drawings of this basic map. Work quickly at first, and gradually slow down to the point where you have maximum control. Start out by trying for a properly proportioned oval, but don't get uptight about it. If I can use these sloppy sketches in the book, you should have no problem making them to throw away. Finish them all, and *think* as you draw. Notice the difference you get when you get a wider or longer oval, or maybe a lopsided one, or when the features are askew. Keep working freely, but your goal is a symmetrical, properly proportioned oval with the features in the right place. Place the eyes first, then the nose, and finally the mouth.

Look at your drawings the next day (before you throw them out), studying them critically both for accuracy and to understand how moving features and proportions affects the way you feel about the person you're drawing.

When you *know* that your hand will do exactly what your mind tells it to do, you're ready to stop filling your wastebasket and move on. I can't overemphasize the importance of developing the attitude that these studies are not masterpieces. They should be discarded when you get what you want from them.

LEARN TO TRUST YOUR EYES

There's one thing about drawing: You will never totally leave the basics behind. You will likely come back to them often to sharpen your sense of basic proportions. But there will come a time when you need to approach your drawing with the confidence that you can see the big, simple shapes of a particular head, and put them down right away without this crutch.

The big problem with using a formulated approach to learn to draw is that it can get in the way of learning to see the actual shapes and forms in front of you. You need to look at things for yourself, and learn to see them as they really look, not symbolically. Someday you may consciously want to work with symbols, like some of the more primitive artists who call themselves modern do, and we will discuss that later, but that isn't the kind of drawing we're working on at the moment.

By understanding that the human head comes in many diverse shapes, sizes, and proportions, we realize that we really don't have to draw the basic map with any precision. We simply use it as a framework to build from, and to learn its general structural characteristics.

This way of studying the head is undoubtedly older than Leonardo da Vinci. Most of the systems I've seen are way too complicated to actually draw with, and in many cases are actually wrong. I have purposely simplified things, and knowingly used slightly inaccurate proportions to make things workable without using any measuring systems. I urge you to draw by eye while learning. Save your measuring for drawing portraits, or for checking your results after you're finished. If you don't, your sense of proportion will never develop.

There isn't quite enough room between the nose and the chin in our map to perfectly fit in a mouth without crowding it slightly. Since it's much simpler to visualize the halfway points when you start from the big shape, and since each face is different anyway, this turns out to be the best system that I could come up with.

The positioning of the features in a head is far more important than the details of the features. I am mystified that so many books stress the drawing of the individual features in detail so strongly when in fact this is such a minor part of learning to draw the head. One of the biggest faults with many portraits is that the features are delineated much too clearly, breaking up the unity of the head.

From now on, I want you to concentrate on dropping the beginner's habit of outlining things with skinny lines. It's much easier to place a big area of tone accurately than it is to start with a tight outline. For

instance, eliminate the actual eyes altogether and put in the big socket area first. Wherever you can reduce anything to a simple mass, that's how you draw it in. You'll find it much easier to place an eye properly in a socket shape than to position it in a big blank head. It's also easier to sense where a bigger mass fits into the big puzzle than a smaller one. Finally, you get a much quicker sense of the solid form when you start this way. Often you won't even need to carry things beyond this lay-in stage, because it usually looks much better without all the fussy detail.

THE MAP IN USE

We end this chapter on the basics with a photograph of the head that features almost perfect classical proportions and structure.

I have superimposed our map over a lightened print of this photograph, and it fit perfectly. If you were to move any of the spots even slightly, you would completely change this woman's character. When you learn this map well enough, you'll be able to sense slight deviations from these proportions in your sitter, and that will be a great aid in getting a likeness. Note the dark shapes around the eyes; we'll add these to our map in the next chapter to better see the simple, solid aspects of the head. We're also going to reduce the map to front and side planes to make it easier to sense the solid forms.

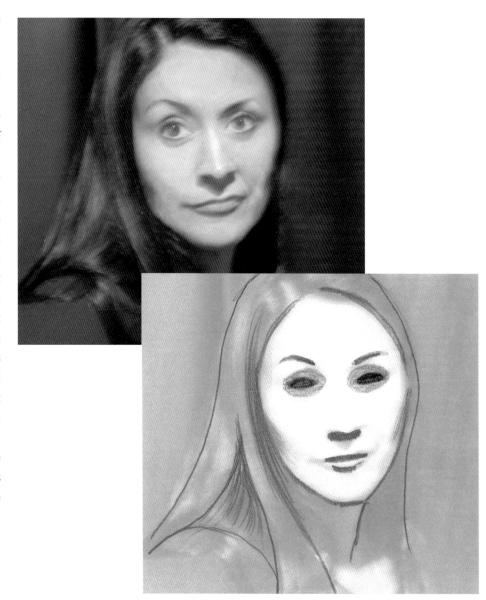

CHAPTER TWO
DIFFERENT VIEWS

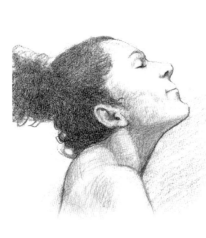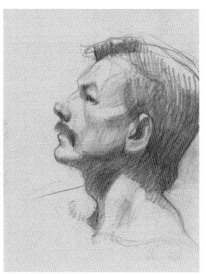

Let's find out what happens to our basic map when we turn the head at different angles.

START GETTING CONTROL

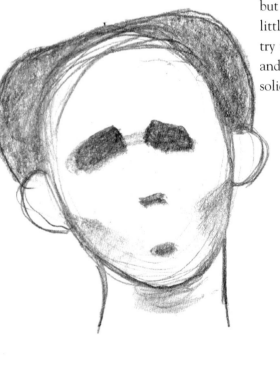

The first chapter gave you a basic concept of how heads are proportioned from the front view, as well as an introduction to simple drawing. In this chapter we get right into serious drawing. You're going to have to put some real time into this in order to develop your sense of proportion and bulk. Still, this work will pay big dividends, and it should also be great fun as you see your improvement along the way.

We'll now expand our simple skull map by drawing eye sockets around where the eyes should go, and adding a couple of smudges of tone under the cheek area. This time, try to get a little more symmetrical with your basic oval shape. Keep your drawings much lighter than mine here—you'll eventually draw right over them to finish up your drawings.

Also experiment with changing the proportions slightly by widening or narrowing the big oval shape a bit, and by moving the features into slightly different positions. Maybe lower the mouth or shorten the nose, put more or less space between the eyes, add eyebrows and move them up or down, try adding a beard, change the hairline, and so on. In other words, have a little fun experimenting, but don't change things drastically. Carefully observe the effect that little changes have on the face. Once more do a lot of drawings, and try to get a little more control of things. Try to keep your lines loose and free. Notice how this simple map has a tendency to feel like a solid form rather than a flat shape.

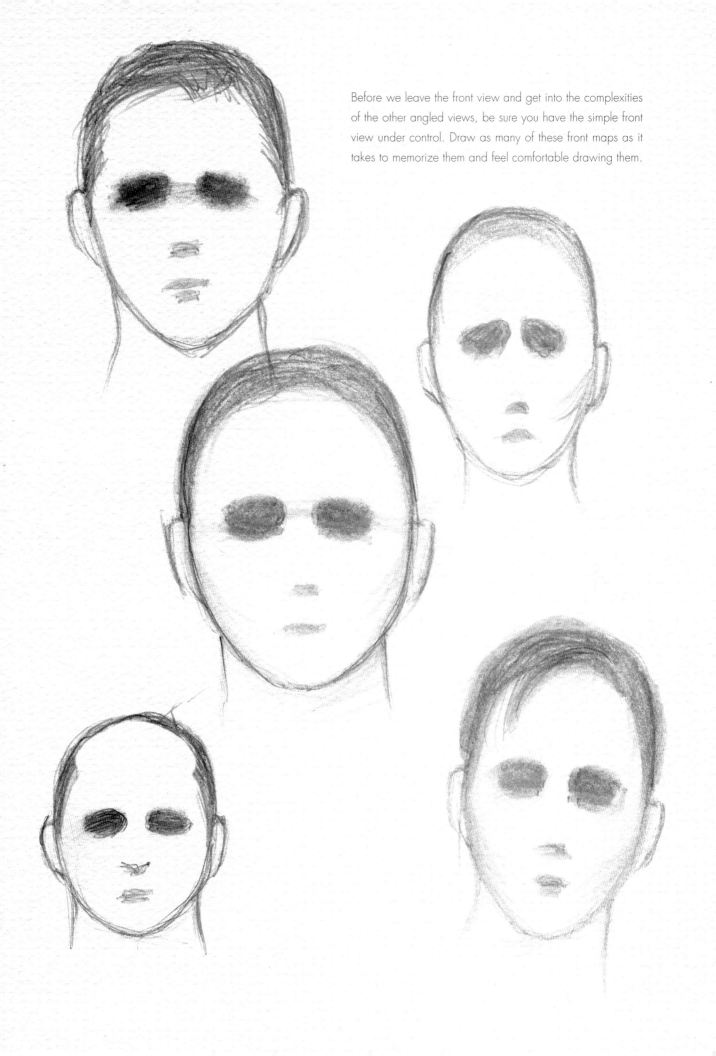

Before we leave the front view and get into the complexities of the other angled views, be sure you have the simple front view under control. Draw as many of these front maps as it takes to memorize them and feel comfortable drawing them.

DIFFERENT ANGLES

When you're drawing a head, you don't always have the option of a straight-on front or profile view. Most heads and faces look better from an angle. This is our next area of study.

Drawing 1 is a full-profile view. It shows the widest possible view of the head. The full-front view (number 4) is the narrowest. All the other views lie somewhere in between, each getting progressively narrower as it approaches a full-front view. Note that the heads are all drawn with the same inverted teardrop shape, slightly modified in each.

I have drawn a centerline from the chin to the hairline in each view. It becomes more vertical as the angle approaches the front view.

Since the eyes fall behind this line in the profile view, the far eye will fall behind the bridge of the nose in the near-profile views. There is a slight indent in the contour by the far eye in drawing 2. Here the eye gets crowded between the bridge of the nose and the contour.

There are other views to be considered before we finish our analysis of the placement of the features, but right now let's take a look at turning the map into a solid, fully rounded, three-dimensional framework that you can build your drawings from.

The mental process of learning to see a solid object on a flat surface is where artists have most of their troubles. You're going to have to see your subjects both as the solid, three-dimensional objects that they really are, and as flat patternlike shapes, which is what they become when you transfer them onto your flat paper or canvas. When you work from imagination with no model or copy to work from, you are forced to visualize the solid forms before you rough things in because you have no shapes to compare your work against. When you have a model to work from, *get the flat shapes right, and the solidity practically takes care of itself.*

Periodically step back from your drawing and focus your eyes on its center, then "spread your vision" to take in the whole drawing at once. This gives you a slightly blurred look at your whole drawing and helps you switch to the proper mode of seeing to catch any distortions or misplacement of details that might come from thinking dimensionally while actually working on a flat surface.

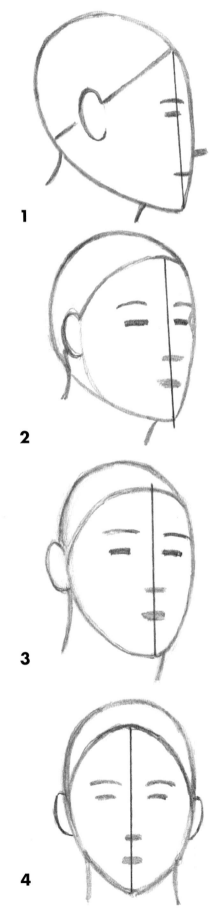

1

2

3

4

GET IT SOLID

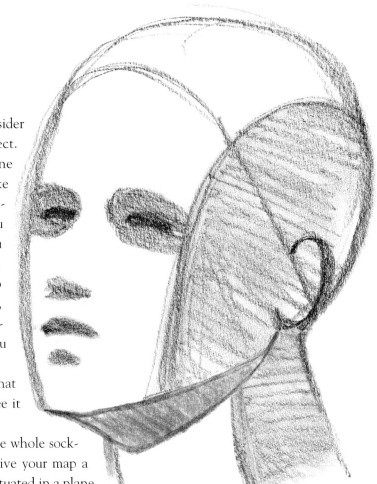

To repeat, when you draw, you need to consider both the form and the shape of your subject. They ultimately come together to form one image, but they can be studied separately to make the drawing process easier. When you work without a model or copy, as you're doing here, you need to visualize the form or solidity before you start drawing, and that makes the process harder. You're working on a flat surface and have no shapes in front of you to check your work against, so you need to be doubly careful now that distortion does not creep into your drawing when you think of it as solid.

Let's turn our map into a solid framework that you can build your heads from, and get you to see it that way with as little distortion as possible.

First, instead of drawing an eye, block in the whole socket, as in the illustration below. This begins to give your map a skull-like feeling. This is logical since the eye is situated in a plane that sits under the forehead at an angle. In most lighting situations it will be darker than the main mass of the face.

Now make two marks instead of one for the mouth position. The top mark represents the upper lip, while the bottom one is the shadow below the lower lip. This is consistent with the dark shadow in the eye sockets and the dark mass on the side of the head.

Imagine the teardrop as a solid rounded shape, and slice the sides off as in the illustration below.

You should now have a reasonably accurate map of a generic head that has a sense of solidity. It has a frontal plane, side planes, and a back. This is very much like the way professional portrait painters might block in a painting—except, of course, that they need to be very accurate in their observation of the sitter's proportions and feature placement.

Your job now is to draw the head in every conceivable position, including having it facing in both directions, and make it look as solid and undistorted as possible. For now, you can consider the side planes and the eye sockets in shadow, and put a light tone over them, as I have here.

THE PROFILE VIEW

The profile view is actually easier to draw than the front view because its silhouette carries more character information than a straight-on front view. I am not going to guide you step by step through the drawing process any longer. I wanted to get you started drawing as quickly, and with as little fuss as possible. But I've learned from my own students that there's little value in having your instructor hold your hand while you draw. When you think things out for yourself, they stick with you, and that's when you really learn. When things are handed to you neatly packaged, you might grasp them superficially, but you haven't understood them in any depth, and they tend to ultimately get lost in the subconscious mind.

Now, we all know that there is no actual formula that everyone would all agree represents an average head. Just have a look at the first ten people you see to put that idea to rest. There are millions of people out there and they are all different. I arrived at this basic formula by starting with the whole, then breaking it and its parts into rough halves to keep things simple when you're actually drawing. You could do this easily by eye; you don't need to measure anything as you work (unless, of course, you're doing an actual portrait). This works well in a straight-on front view, but becomes slightly more complicated in the side, and other views. There's no way around it: You're going to have to develop a discerning eye to draw well. Obviously, everything you learned about the front view is also valid in the side view, though it needs to be applied differently.

You might as well get into the habit right now of thinking a little more deeply as you look at this book's illustrations, because I will gradually push you more and more into that way of thinking as we get deeper in. Take a careful look at the drawings on the facing page and see what you can get from them by simply studying them carefully.

Here are some of the things you should observe in these drawings:

- The profile view is wider in relation to its height than the front view. It can almost be related to a full circle.
- Its basic shape can be compared to an inverted teardrop, with its point culminating at the chin.
- As with most of the views, it can be roughly plotted with three lines.
- If the ball section is divided into quarters, the horizontal or brow line will run right across the top of the eye sockets.
- The facial line drops down from the horizontal line.

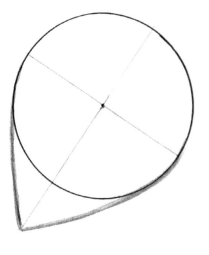

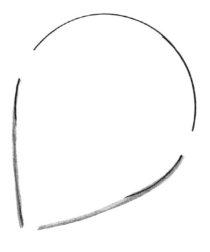

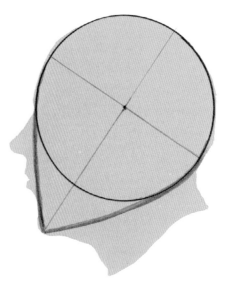

The basic teardrop shape

Three lines can define and place the basic shape.

How the profile fits over the teardrop shape.

- The eye sockets sit at an angle behind this facial line.
- The base of the nose sits on it, and the tip is in front of it.
- The mouth also falls on the line.
- The ear fits into the lower rear quarter, with its top at the junction of the lines.
- Remember the hairline from the front view? Here it could be the diagonal line at the top of drawing 1.
- Note that I flattened the sides of the ball.
- Note the soft, toned line that runs down the side of the face, separating the front planes from the side planes. Also see how it runs down the temple area, along the eye socket, and around the cheekbone down to the chin.
- The neck comes into the head at an angle.

This is how you analyze things as you study them. Keep trying to simplify them. You will find that the things you observe for yourself stick with you.

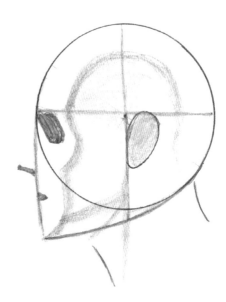

The skull map in profile:
- The eye plane sits behind the face line.
- The nose sits in front of it.
- The mouth sits on it.
- The ear is in the lower rear quarter.
- Note the flattened side plane.

TIPPED PROFILE AND FRONT VIEWS

When the head is tipped toward you, the whole top of the head becomes visible and the head appears longer. The eye sockets are seen at an angle and appear narrower. They're also lower. The nose appears longer.

When the head is tipped away from you, it appears shorter, The eye sockets are bigger because you're looking straight at them. They also are higher up, making the forehead much shorter. The jaw is bigger. Note that the ears are lower when the head is tipped back, and they get higher as the head tips forward.

These are just a few observations. Study the drawings more carefully to see if you can understand the reasons for these changes—and maybe find a few more of your own.

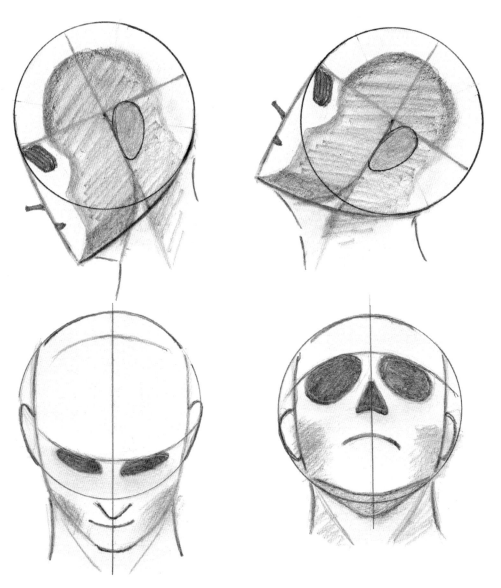

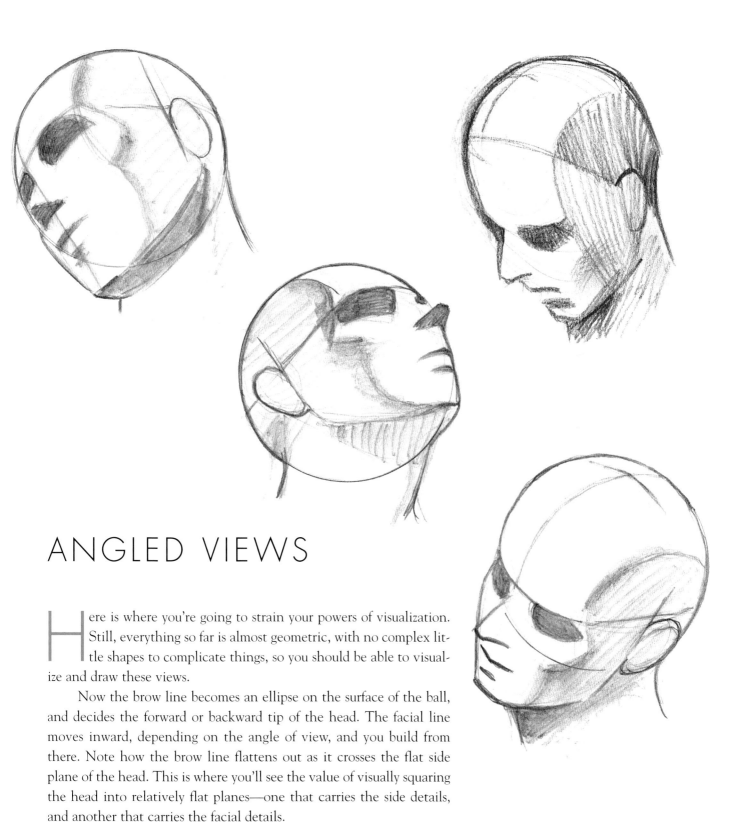

ANGLED VIEWS

ere is where you're going to strain your powers of visualization. Still, everything so far is almost geometric, with no complex little shapes to complicate things, so you should be able to visualize and draw these views.

Now the brow line becomes an ellipse on the surface of the ball, and decides the forward or backward tip of the head. The facial line moves inward, depending on the angle of view, and you build from there. Note how the brow line flattens out as it crosses the flat side plane of the head. This is where you'll see the value of visually squaring the head into relatively flat planes—one that carries the side details, and another that carries the facial details.

It will take a great deal of thought to place things right, but the process will come to you if you keep drawing. Imagine how difficult it would be if you were concerned with the details of the features at this point! Use the brow line and facial line to build from. Remember that the eyes angle down from the brow line *behind* the facial line. The nose and mouth have their centers *on* the facial line.

WHERE ARE THE DETAILS?

Some of the drawings in this book were done during figure drawing sessions, and were actually much smaller than they are reproduced here. This is the reason for the roughness or texture in some of them. Drawing 1 is one of them—originally, this head was only two inches high. It was done with a conté crayon. The eyes are nothing more than shapes of black with soft edges. The hair is merely a textured dark shape with a few lines in it. Yet this could be considered a finished drawing. In some ways, it's even more expressive than drawing 2.

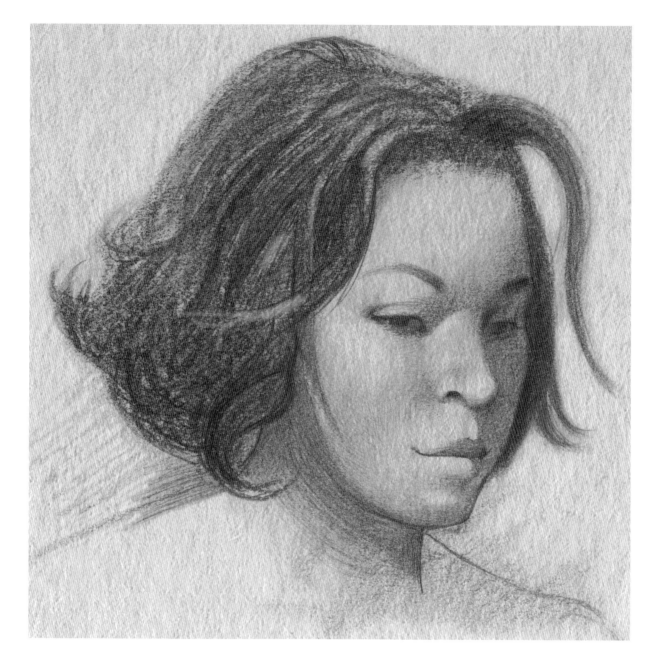

Drawing 2 is the same head carried a little farther. The eyes now have lashes, pupils, and irises. Note that the whole eyes are dark gray; there is no white or highlighting in them. In fact, if you step back a bit, they still look like solid, soft-edged black shapes. Carefully delineated eyes would have ruined this drawing. There is a little more work in the hair also, and the overall complexion was smoothed down a little.

This drawing did not need its extra detail, and it's really no better for the extra work. The point here is: *Get the features placed right; the detail will take care of itself.* Notice that the big shapes of the hair and face have been preserved.

MAKING PROGRESS

This part of learning to draw heads—angled views—is important enough to expand on a bit. If you cannot visualize and draw a mapped head in every conceivable position without copying my drawings, it's very unlikely that you can progress any farther in this book without extreme frustration. If you can, however, you'll find the rest of the book fascinating and relatively simple to follow. I still want you to stay loose and free in your drawings, but it's time to do it with more control. Work very lightly at first, but start getting things more accurate. You can also switch to a soft, thick-leaded graphite pencil if you wish.

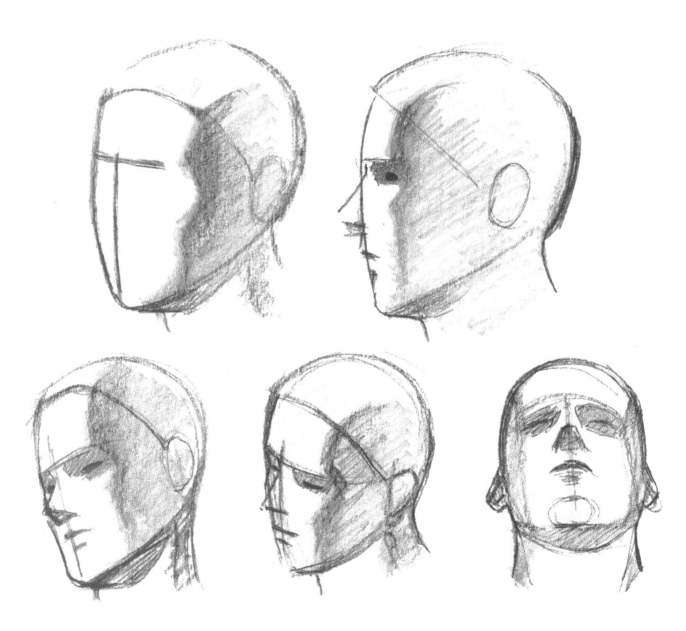

You might want to add a light center guideline, as well as a line that shows the brow position, to determine the angle at which the head is seen. Place an eye mark in the eye sockets, and be more concerned with the shape of the nose. Start getting more character in the edge of the broad tone that separates the side from the front plane, and carry this tone across into the side plane. Notice also that I added a little piece under the chin to make it flow more naturally into the neck.

At this point, keep drawing until you get absolute control over the map. It will take a good deal of practice, as well as thought. Still, even though you'll eventually put it aside for a better way of working, it's still your key to developing your sense of proportion, and solidity, as well as an indispensable tool when you work without a model in the future.

Here are two more heads taken from full-figure drawings done several months apart from the same model. Note the total lack of any detail in the eyes of drawing 1, and the slight indication of eyes in drawing 2. Both are good examples of the importance of a solid structure, and the lack of sharp detail in a drawing. Any more detail would have ruined the effect.

Note the similarity of these heads to our map.

As the overall light increases and spills into the shadow, the details become more apparent, but the power and drama are lessened.

HISTORICAL PHOTOS

As we prepare to leave this chapter behind us, I want you to take a careful look at drawing 1, a pencil drawing. It was made from an old photograph of Chief Joseph. You've probably seen it before, since it has been reproduced many times in history books and magazine articles about Native Americans.

The photo was typical of the times with flat, frontal lighting and probably heavily retouched, so I had to take some liberties with the modeling to accent the planar structure in the head. Although the features are clearly delineated here, the basic treatment is fairly simple, since the photograph was tiny and there wasn't much to work from.

Drawing 2 offers a completely different approach: The focus is on big, solid forms without details. The shadow areas are simple, practically flat black. I was taken by the power of this face, and by the strong forms displayed by the simple light. Note the power and solidity of drawing 2. The whole point of this chapter is to get you to think about solid, simple forms before you put in the details of a head. You can always add them later as you feel the need. Historical photos are a great source of study for the artist, but it is far better, at least while you are learning, to work directly from a live model whenever you have the opportunity. Both of these photos were so small that I had trouble drawing to this size, and had to simplify things greatly.

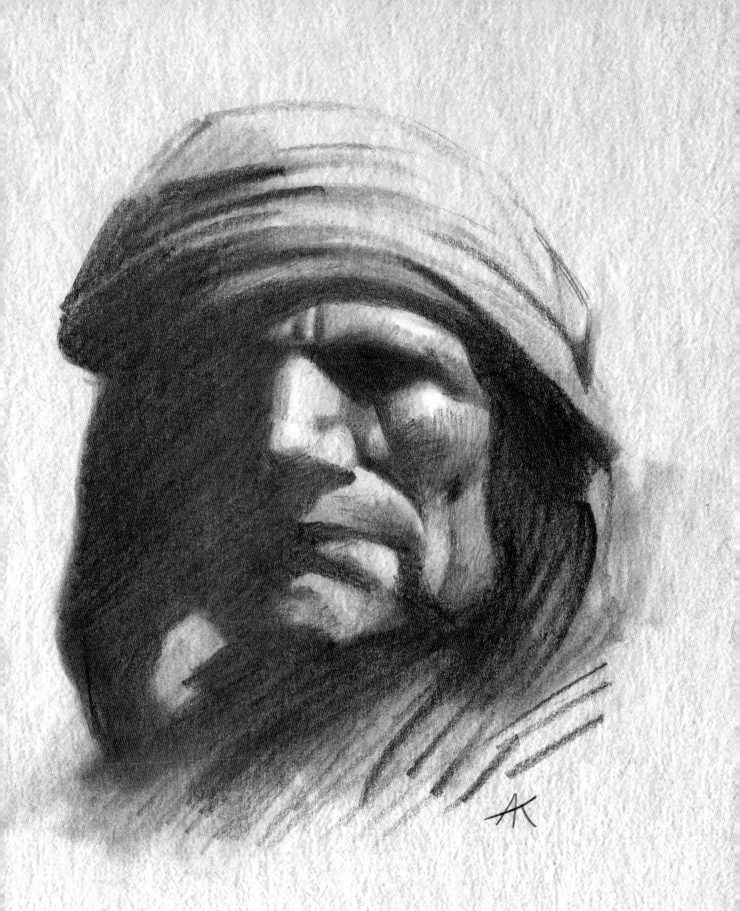

CHAPTER THREE ANATOMY

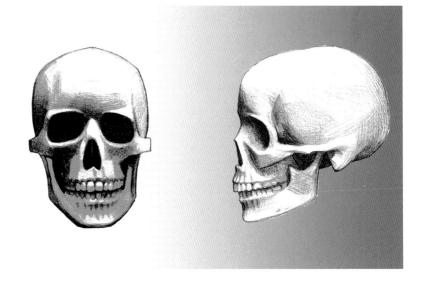

Let's go a little deeper into the basic structure of the head and face to find out what makes us look the way we do.

THE SKULL AND MUSCLES

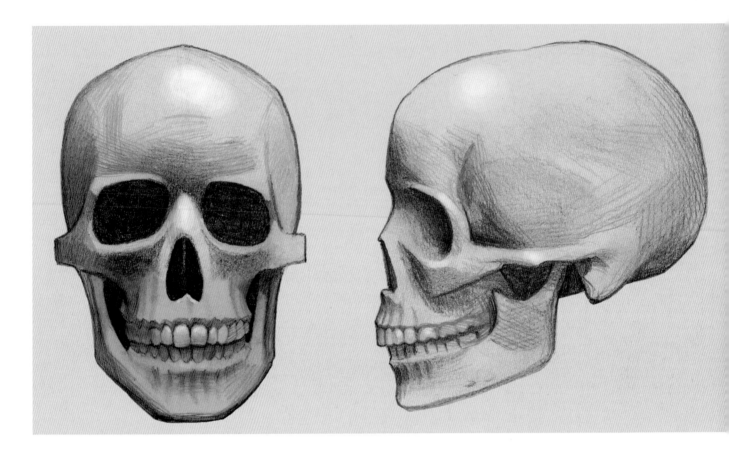

With an understanding of the importance of the big structural aspect of the head, we can now take a look at the details.

Although I recognize that it's necessary for certain types of drawing, I'm not a big fan of the study of anatomy when learning to draw the figure. The head is another story, though, and you're going to need the information here.

Unless I find it expedient, I am definitely not going to name muscles or bones, although I have no problem with you learning them on your own. The anatomy of the head is fairly simple, and if you want, you can pick up one of the better books out there to supplement the material here. My focus in this book is strictly structural. You can skip this chapter for now if you want, and pick up pieces of it as you go through the rest of the book. The information is vital, but you should not be drawing the details of eyes, noses, mouths, or ears until you understand how to place them in a properly constructed head.

The Skull

The skull is the foundation for drawing and understanding the head. Except for the jaw, it has no movable parts, which makes the study of the head much easier than that of the body. You simply need to be able to visualize it from any angle. Look at the people around you: You can always see the skull shape coming through in their heads. Notice where the bone comes to the surface.

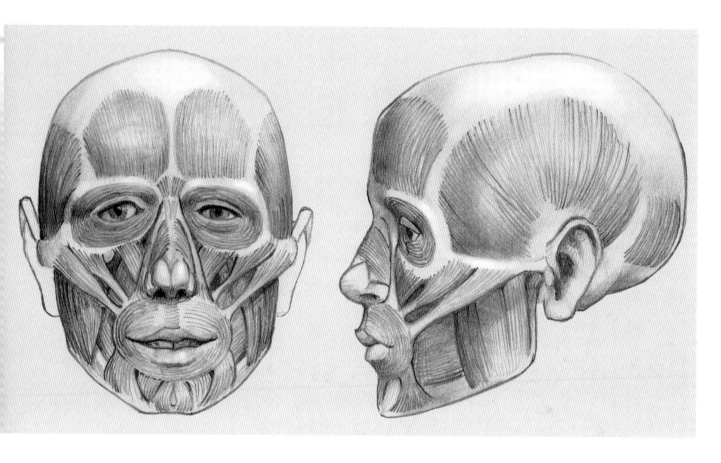

On some faces certain muscles are very apparent. Notice how the doughnutlike sphincter muscles around your eyes and mouth can take on unusual shapes. Imagine the diagonal muscles running from the cheekbone to the doughnut-shaped muscle that makes up the lips, pulling them back into a smile and bulging the cheeks in the process. Think about how the frontalis muscle on your forehead can pull up your brows and cause the forehead to wrinkle.

All the muscles are in the same place in everyone, but they are shaped differently in each of us. This, along with our sometimes dramatic differences in skull shapes, creates an endless variety of heads to draw. But it takes a discerning eye to note, and draw these differences. Study the muscles in the drawings here, and try to imagine their functions. Also look for the bony ridges (in white), and compare these drawings to those of the skull. These ridges are landmarks that add the spark of life to your drawings, as well as helping you in the drawing process.

The Muscles

Feel your own face to see where the bone surfaces. Now touch the side of your jawbone as you clench your teeth and feel the bulge of the masseter muscle under the bony ridge in front of your ear. Look at your face in the mirror and make faces at yourself to see if you can imagine the muscles working under the skin. A muscle can only contract and relax, and it bulges as it contracts.

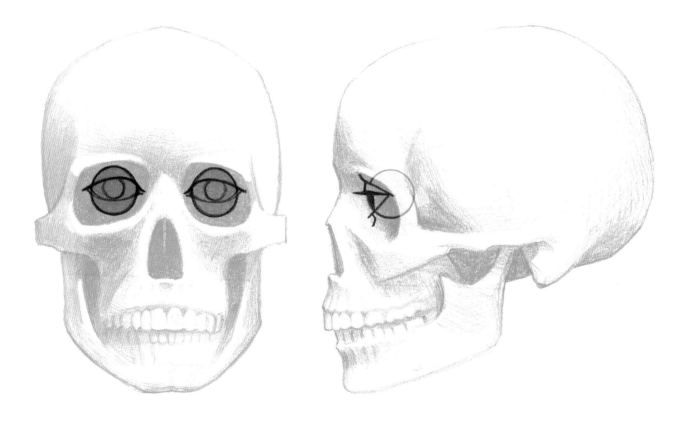

THE EYES

The eyes are two whitish globes set back into their sockets under the protective hood of the forehead and brows. They're surrounded by a doughnut-shaped muscle attached to the edges of the bony ridge that surrounds them. The muscles that actually move the eyes are hidden and have no significance for our purposes. The eyes are on a slanted plane that generally gets less light than the surrounding planes, which is why it looks right when we darken the whole socket area when drawing the map.

The underlying ball structure is always evident when you look at an eye. The lines of both eyelids conform to this ball as they enclose it. The top lid is thicker than the bottom lid, and with its lashes it always casts a shadow over the eyeball, making the white part of the eye almost always darker than you think it is. This is also why drawing the whole visible portion of the eye as a simple dark shape looks more real than an eye with all the details drawn in.

The tissue surrounding the eyes is soft, and often gets puffy and discolored. It should be drawn very carefully if you don't want a sickly or tired-looking subject in your drawing. Often it sinks in and

shows the bony ridges around the eye too prominently. You can be kind to your model by deemphasizing this.

The amount of pupil that shows is critical when you are drawing an expression. Generally, in a relaxed state, the upper lid covers about one-third of the iris.

The eye is the most expressive feature in the face. Strangely enough, the eye itself is not responsible for its huge range of expression—it's the surrounding features that cause us to look angry, happy, sad, sleepy, and so forth. The eye above is not the usual symbolic eye drawn from imagination to demonstrate its structure; it's actually my left eye, drawn while I was looking in a mirror (trying to see around my glasses). No matter how experienced you are, there is a noticeable difference in the results when you work from life and can actually study the real thing as you draw. Compare this eye to those on the next page, which were drawn from imagination. You should be able to see the difference. Notice that I include all of the area inside the whole eye socket, since this is ultimately the determining factor in showing a person's expression, age, and other vital factors.

Spend a few minutes in front of a mirror making up some expressions, and concentrate on your eyes as you do so. Take note of what you learn while looking at yourself before you continue in this book. Let's see if you are beginning to learn how to look at things, and what to look for.

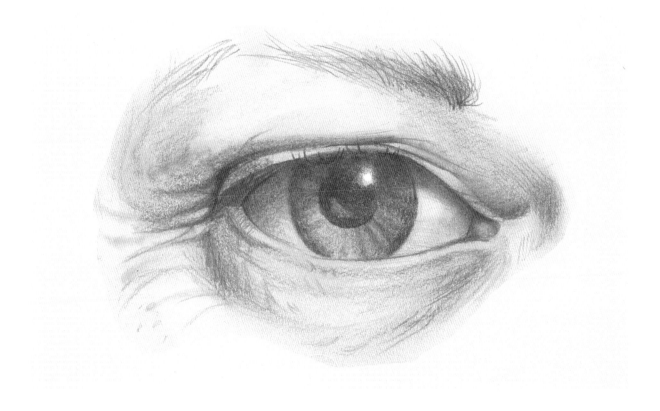

THE BASIC SHAPES OF THE EYE

The Ball

The eyeball sits back deeply in the socket, but it's rounded shape is always evident.

The shape of the bony socket lies beneath the layers of muscle and skin, but enough of its structure comes to the surface to influence the forms that make up the eye. Be conscious of it.

The Shape of the Eyelids

Imagine a rubbery sheet attached to the edges of the socket, with a slit cut into it to allow the ball to show through. It takes on the rounded form of the ball. This is the orbicularis oculi muscle—a very soft, flexible circular muscle that's responsible for opening and closing the eye. Note the rounded form that's evident even if the eye is closed.

The Teardrop Shape

The teardrop shape starts at the pocket next to the nose and curves up over the eye, widening out at the temporal area and bulging over the upper eyelid. This creates the fold that's usually prominent in the Caucasian race—although it seems to be absent in some people, especially among Asians. In some cases it seems to sink inward and make the bony ridge stand out; in others the overlapping fold looks more like a thin crease on the eyelid.

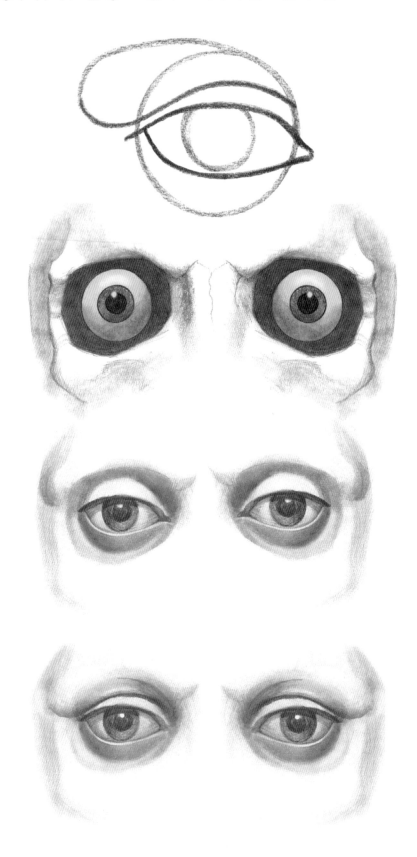

The Eyes Have It

Study these sketches of eyes to see what expression you think they convey. The amount of white that shows has a great bearing on the expression, but it takes the whole face to give a clear, full impression of a mood.

In some heads, especially in older people, the skull shape and bone structure around the eyes are easily seen, and the fold over the eyelid is missing. In others the fleshy bulge over the eye sags and practically hides the eyelid, causing wrinkles at the corner of the eye.

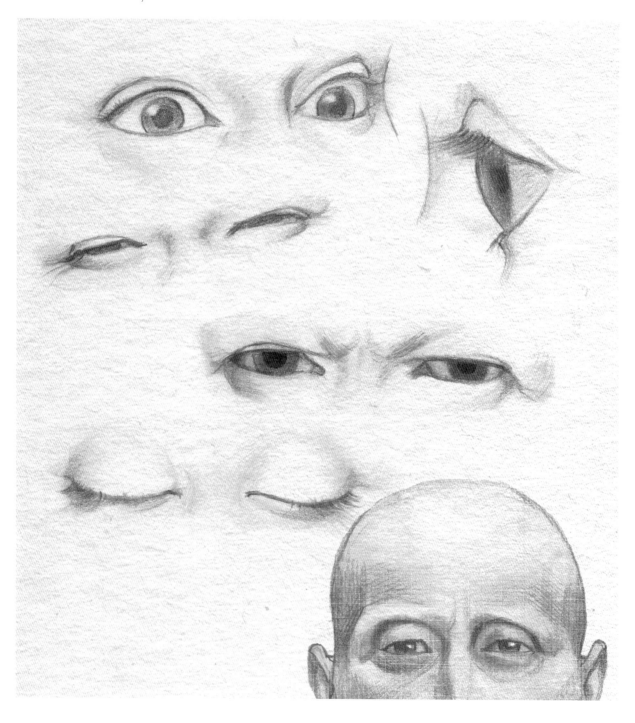

THE MOUTH

ike the eye, the mouth is surrounded by a sphincter muscle, which gives it a great range of motion. It is deceptively hard to draw, and should be carefully studied. It also is very dependent on the surrounding tissue for its shape and expression.

Lips and mouths come in all sizes and shapes, but, as usual, they are all constructed the same. Once you understand how they're put together, it's a simple matter to adjust the factors the way you want them.

The teeth form a solid curved surface against which the soft tissue of the lips pull, stretching into an unbelievable display of shapes. The lips are quite thick, and the teeth are set back deeper in the mouth than you might expect. One of the big problems you encounter in drawing the mouth is the tendency to make the teeth too white, which brings them forward and makes the lips look thin. It also destroys the unity of the head. This is particularly troublesome in portrait painting, where a likeness is paramount, yet a subject insists on unnaturally white teeth. Fortunately, most portraits have the mouth closed.

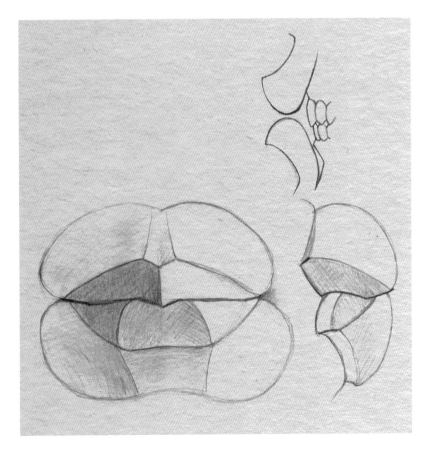

The Lips

The construction of the lips is more easily understood if you reduce the upper lip to two flat planes, and divide the lower lip into three planes.

When you think of the mouth, always consider the full area around the lips. That will help you avoid giving lips a flat, pasted-on look.

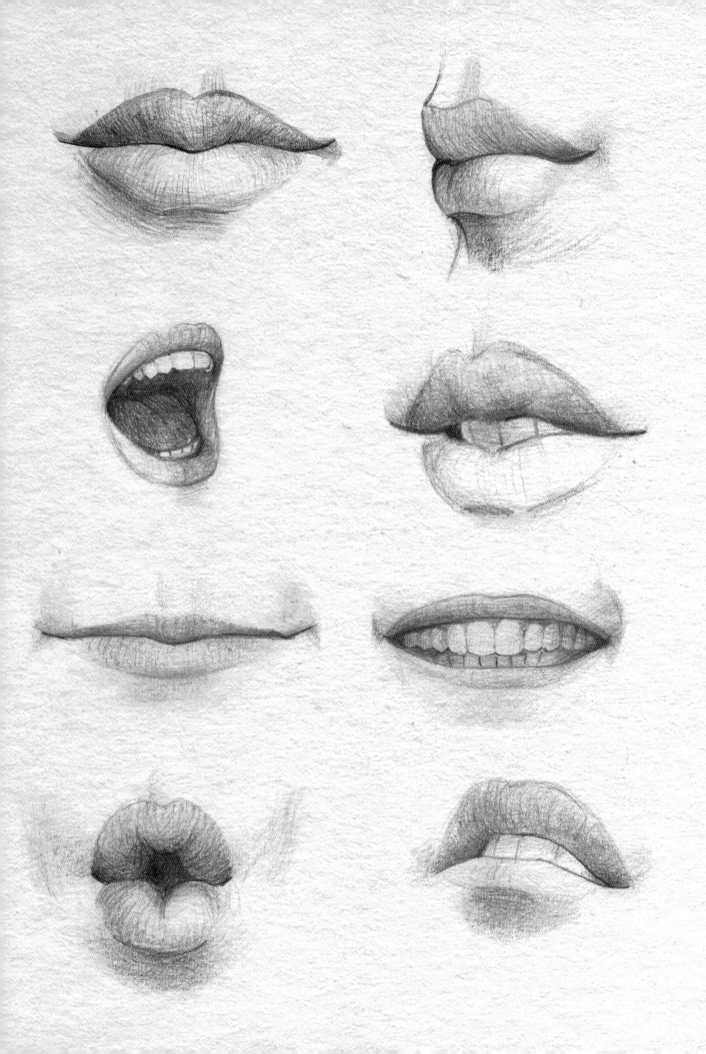

THE NOSE

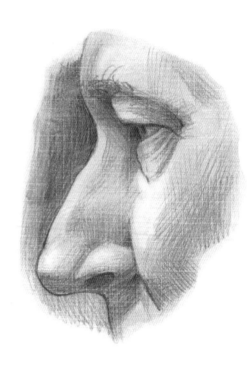

Since it so strongly influences our profile, our nose can be a powerful identifying feature of our face—more so than the eyes or mouth. A quick look at the skull tells us that less than half of the nose is bone; the lower part is cartilage. This cartilage can take on many shapes, but as usual it can be broken down into a few basic shapes (four in my model). I have numbered them; you can name them if you want. These shapes can be very prominent, or they can flow so smoothly into one another as to be practically indistinguishable from each other. In some, the bulb (A) is so big, it seems to hang down; in others it's quite small. Sometimes the ridge (B) is convex and forms a hump, while in others it can be concave and form the "ski nose" shape. As always, keen observation is the key to getting believability in your drawings.

Look for the basic simple planes when blocking in a nose. Get the overall proportions right before you start breaking down the smaller shapes.

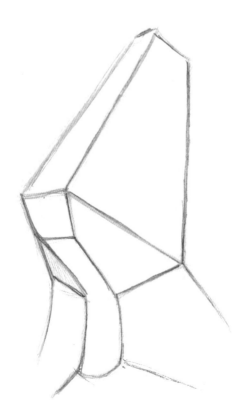

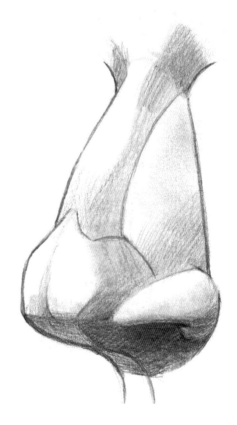

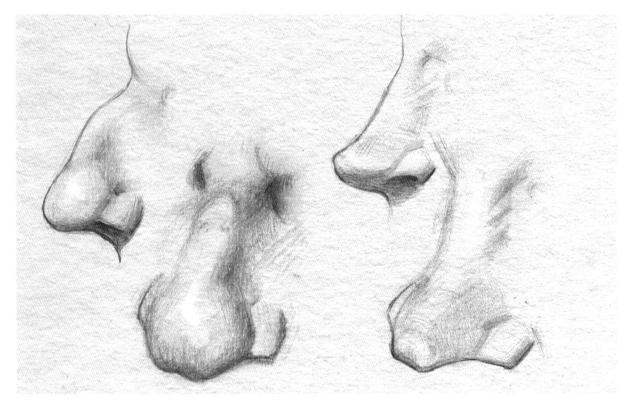

TYPES OF NOSES

The variety of forms that these four shapes can mold themselves into is endless. Surprisingly, as you study them you'll find that they seem to fit into three or four groups, but they vary in length, width, and size to such a degree that when surrounded by different features, they make up millions of faces, and no two of them are perfect matches.

It might be argued that the little triangular shape that bridges the connection of the nose and forehead should also be considered a shape of the nose. I can see no point in making an issue of this, but it certainly does affect the character of the face and should be noted. All the shapes surrounding any of the features affect both the feature itself and the whole face. In the end they are simply part of a whole entity, and should be thought of in that way.

The two drawings above are slightly exaggerated examples of the opposite ends of the spectrum of nose shapes. One is convex with large, bulbous cartilage at the end; the other is concave with smaller, sharply pointed cartilage. You will find that most noses fall somewhere in between, or in combinations of these two extremes. As people get older, their characteristics become stronger and more obvious. It's harder to see the separation of the various planes in young people's features, so look for older models to study first. When you're drawing young faces, deemphasize these things or you'll add years to your model unintentionally.

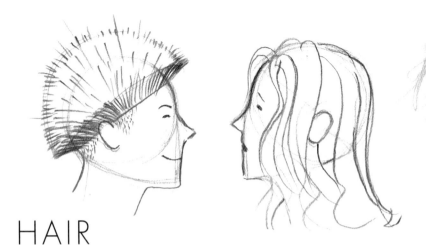

HAIR

The full half of the globe that makes up the cranium is capable of growing hair. That includes everything above the diagonal hairline in our map. This line actually varies in everyone; our line simply establishes a general area. There is almost always hair growth in front of the ears, and in men it grows downward over the whole lower portion of the face, to include sideburns and beard. It also grows below our line at the temples. Observe this general overall shape of the hair mass carefully, because it's an important characteristic of each head.

Hair tries to grow straight out from the head, and if it were rigid enough, it might look like drawing 1. But since it isn't that rigid, it tends to grow straight a little way, and then hang down with its ends curling softly, more like drawing 2. We do the best we can to control this situation by cutting, brushing, combing, pinning, or tying it up in many different configurations. Of course we all know that hair can be straight, curly, thick, thin, stiff, or limp, and these conditions all contribute to the look of an individual.

The thing that makes drawing hair seem so hard to novices is that they *know* it's made up of thin strands, and they expect to have to draw in every one to get a drawing to look right. But take a careful look: You can't see these tiny strands unless you're right on top of them, and even then they tend to mass together into much thicker shapes. Once you realize that, you give up trying to draw every strand and begin to see the general flow of the big masses of hair. You'll find that hair is actually much easier to draw than the rest of the head.

Think of the whole mass of hair as one big, simple shape (drawing 3). You don't even need to get all worked up over the sparkling highlights you see all over the hair mass. In many drawings hair can almost be left as a simple flat shape if you keep some edges soft, pulling a smooth line through here and there to set up a flow. Study the overall shape for the flow that is set up by tumbling masses of hair, carefully study the edges for little curls and occasional errant hairs, and indicate these things with long, gracefully curving lines. Then softly put in the big shadow areas and any major darks.

You do have to be sensitive to the beautiful rhythms that these masses make as they conform to the basic natural laws, but don't try to copy every little wiggle or shape you think you see. That just complicates things unnecessarily.

THE EAR

The ear is the most neglected feature of the head. We draw it because we have to, usually just roughly indicating it and hoping we can get away with that. Of course, a badly drawn ear will ruin a portrait or even a casually drawn head in any drawing, so you might as well study the shape—they're present in every ear. They just take on wildly different proportions, like all the other features do.

The correct shape of a specific ear is important in getting a likeness. The easiest way to draw these curved contours with any character or accuracy is to block in the ear with straight lines first. You'll find it much easier to see where the line moves off in another direction if you reduce it to straight segments where possible.

Once again, I'm expecting you to analyze and reduce the ear down to its simplest shapes without my pointing them out to you. There are four things that happen in every ear, and if you find them for yourself, they will stick with you. Even if we don't see it the same, you will gradually develop the habit of doing this and learn more quickly because of it.

We're now going to leave this highly detailed stuff behind us and get back into some serious structural work. You might want to switch to a more sharply pointed graphite or charcoal pencil while studying the features, although you can use your crayon if you prefer—just work a little bigger. Do not let these relatively insignificant details interfere with your ability to see the big, whole shape of the head first. That, and the placement of these features, is the big thing. You can actually do beautiful heads without ever drawing a feature in full detail.

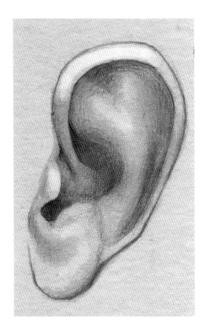

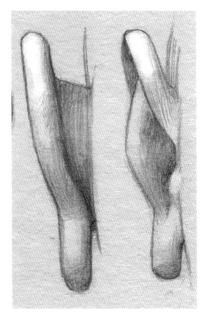

CHAPTER FOUR THE ESSENCE

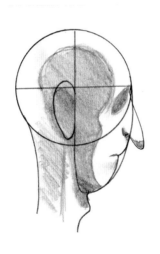 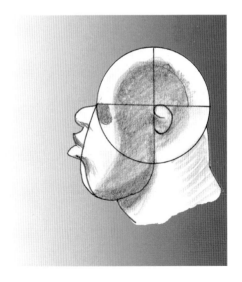

Let's lighten up and have some fun while we work on this critical but misunderstood and neglected part of learning to draw heads.

RECOGNIZING THE ESSENCE

The ability to recognize the characteristics of a head that set it apart from others—in other words, its essence—is basic to any type of portraiture. In this chapter we're going to take time out to have some fun, and at the same time develop the visual skills that set you apart from other artists and give your drawings of heads much more individuality. We're going to explore what I feel is one of the highest forms of portraiture—caricature.

Every head has a special character that makes it unique. I have found that heads can actually be grouped into types; if you're sensitive to these things, you'll know exactly what I mean. For instance, when I was a child and got to know a girl named Emily, I developed a preconception of what an "Emily" looked like. From then on, whenever I met a person with her basic characteristics, I would think of her as an "Emily." This happened with almost every new person I met, and I soon found that there seemed to be certain shapes or combinations of features that repeated themselves into families or groups. Of course they were not all named Emily (or Florence, or whatever), but I grouped them by name anyway.

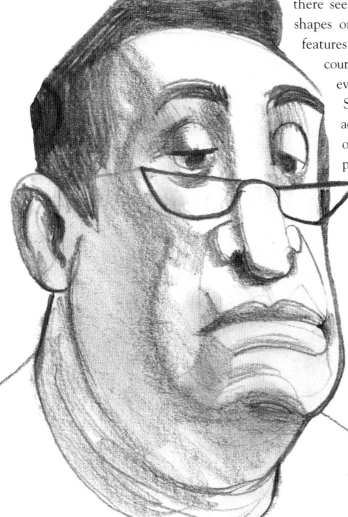

Some people have easily identified basic shapes and characteristics, and others give them up reluctantly, but everyone has them. A thing worth noting is that the beautiful people, the Hollywood types, turn out to be very average in their shapes and proportions. Unless they have a special thing going—a special hairstyle or something else that can be easily identified with them—they can be quite a challenge to draw convincingly.

The fellow to the left at the bottom is my recollection of a client that I had twenty years ago. He had such a strong individual shape and character to his face that I could clearly draw him today. This drawing brings him back to me much more forcefully than any photograph could. This is the essence discussed in this chapter.

ANALYZING THE HEAD

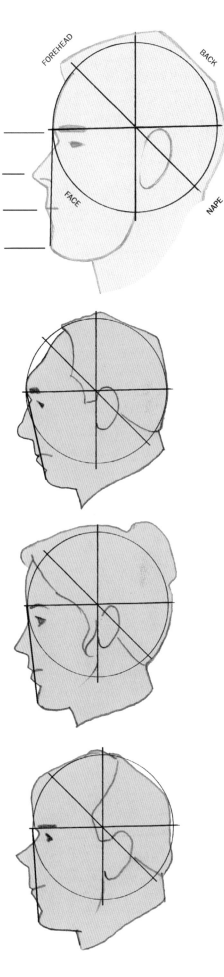

This will be our last project using "crutches" to help with the visualization process. This is a completely new way of analyzing and understanding the specific characteristics of a head. It looks more complicated than it is. Once you understand how it works and put it to use, you'll find it much easier to instantly grasp the specific character of any head you're drawing.

Let's have another look at the profile. It carries the key to the essence of a head. Even though you are drawing another view, if you take the time to study the profile, most of the head's secrets will be revealed to you. It's simply a matter of knowing what to look for.

Remember our circle? Here it is again divided into quarters with a diagonal through it, placed over different profiles. By studying these drawings, you learn many important facts.

There are three roughly equal spaces locating the hairline, eyebrows, base of the nose, and chin. The hairline begins where the diagonal meets the circle at the forehead. Note the facial line running from the brow to the chin.

You can name each quarter. One contains the forehead area, another the back, a third the nap; the fourth holds the face. The diagonal represents the hairline, as it did in our map. Above it in a full half circle is where you will find the hair growth. Of course this line varies in all heads; it usually comes down in front of the ears slightly, or goes back in a balding man to reveal more forehead. The ear sits completely inside the nape quarter.

When studying a head, look first at the forehead. Does it slant back farther from the brow line than our model? Does it go straight up? Is it bigger or smaller than our model? Then check the facial line. Is it longer or shorter than our model? What angle does it take? Is the top of the nose set back from our facial line? What angle does the nose take in relation to the facial line? Is it a short or long nose? Does the upper lip come straight down, or is it angled? Is it long or short? What about the lower lip? The chin? There is a high point on the top of the head. Where is it? Go around a head looking for these and other things. You will find that, after you have a little experience with it, you can automatically visualize this circle on any head and quickly sense the deviations from it. Eventually you'll hardly be conscious that you're doing it.

EXAGGERATING THE DIFFERENCES

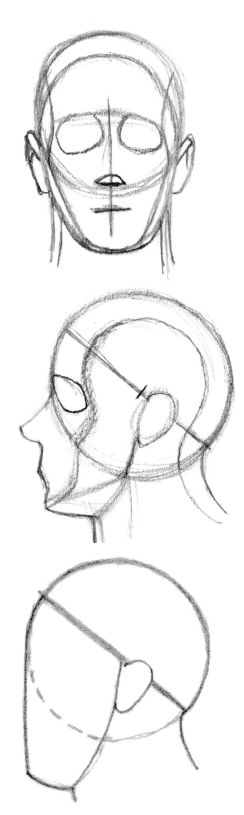

Study these drawings carefully. Note that both views are topped off by a ball. The ball is the thing that I call a crutch—a geometric shape that starts the visualization process for you. Even though they're great learning devices, these crutches tend to inhibit your ability to learn to see the true shape of things. We will dispense with all of them after this exercise, and work from characteristic shapes right from the beginning of a drawing.

Now let's take a break from all this academic stuff and have some fun. Cartoons and caricatures probably don't seem like serious study to you. Well, this is one time you can play around without feeling guilty about it. Because this is indeed very serious study, and it's one of the best ways to learn to see simple shapes and forms as well as grasp the real character of a specific head. It will keep your drawings of heads from all looking alike, which is almost always the case when you work with a system or formula.

Although the cranium differs substantially in every head, the face is the part that we're going to focus on here. Think of the face as a distinct shape as it projects from the ball. Notice, in the bottom drawing on this page, how it comes down from the hairline to the chin at a specific angle, and then goes back to the neck at another angle. These angles determine the head's basic character. Finally it runs back up to the center of the ball. Note how the ear sits right behind this last line, slightly breaking the hairline. The facial line and the line that goes from the chin back to the neck carry a huge part of the character of any given face in the profile view.

Pay close attention the next time you're out among people, and look for these lines. Although they can be difficult to see in some people, each person is unique in the shape these lines make as they come together. In addition, the placement, shape, and size of the nose, as well as the forehead, lips, and chin, on this facial line are critical. Any of these things can be exaggerated in order to heighten the likeness or character you're after. That is why we're going to work in the caricaturist's mode in the next few exercises. You should really let yourself go and enjoy them. If your model seems to have a long face, make it longer. Make big ears bigger, short noses shorter, heavy brows heavier, fat faces fatter; wherever some outstanding characteristic hits you, exaggerate it.

Try self-portraits, too, but be prepared to laugh at yourself.

Here are a couple of fairly different types. One has a rounded, jowly face with a short turned-up nose. The other has a sunken chin and a fairly prominent, slightly hooked nose.

I took a quick glance at each face for an instant impression of these characteristics, and drew them in without careful thought other than to get this basic shape down. In both cases I exaggerated the length of the face. See the top pair of drawings to the right for this first step.

Considering the division into three spaces for the placement of the features, I adjusted them to suit my impression of the faces, and put in the nose, eyes, mouth, and ears in the middle two faces.

The bottom drawing shows how I adjusted the hairline and added a shape for the hair area, as well as some finishing touches throughout. Note that the hair takes on a specific shape, which also amplifies the character of the particular head. I ended up with drawings that aren't really cartoons, but more caricatures of two completely different types. Believe it or not, major adjustments would not have to be made to turn these drawings into portraits. You would approach more realistic drawings by being more careful with the proportions and relationships, but the caricatures here likely have more of the character of the person you are drawing than a more carefully measured work would.

Following is a page of quick sketches done from life, television, and pictures in magazines. Each one was made exactly like our caricatures, although I didn't begin with a ball; I simply put the whole, slightly exaggerated simple shape down, and developed it. None of these sketches took more than two minutes. To me, every one of them looks more like the model than it would have if I'd labored over it.

Try drawing the faces here yourself. Don't copy them; simply look for their character, and put it in quickly. But more importantly, go out among people and draw this way. Or draw from your television screen, or magazines and newspapers. Look for profile views at first. Be sure to keep this fun. Don't get all uptight about every drawing; you're going to make more bad ones than good ones. You're training yourself to see the essence, and you will make progress if you allow yourself to see and exaggerate the simple shapes.

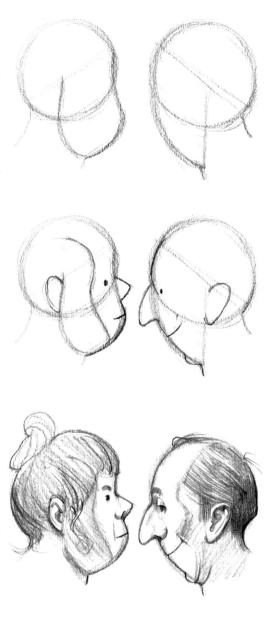

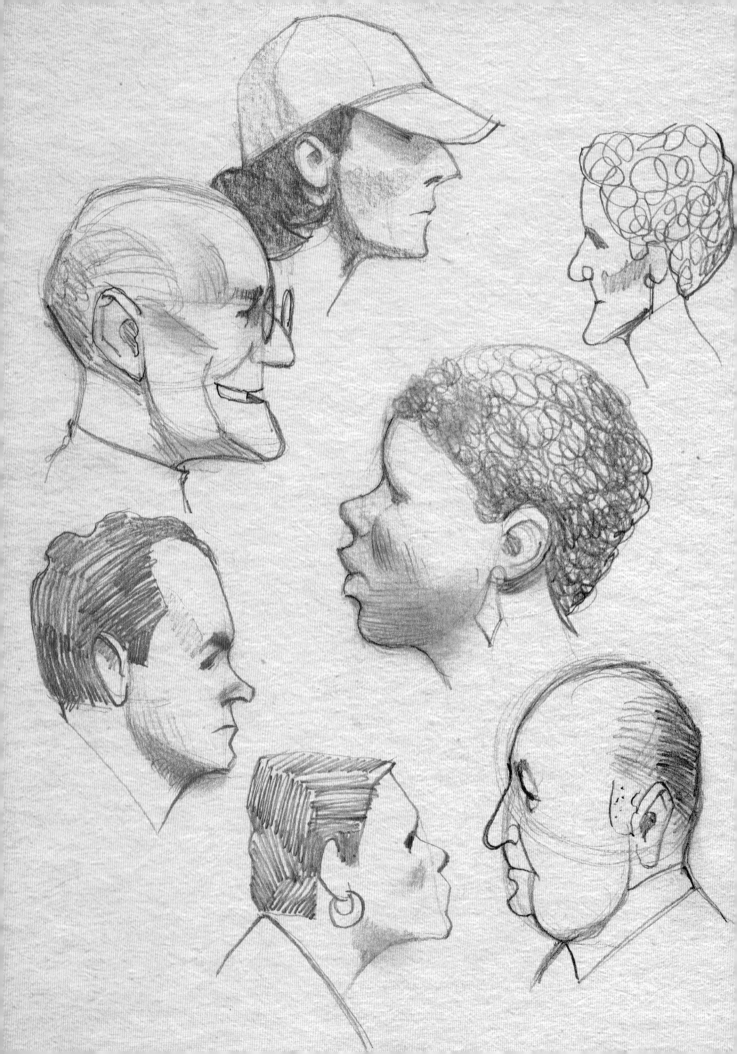

DIFFERENT ANGLES

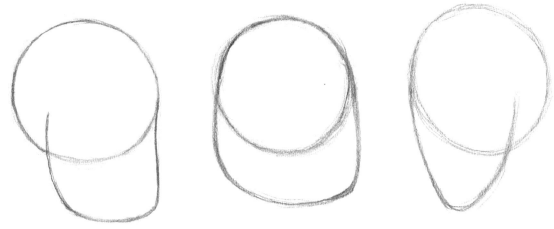

The same logic applies for angle views: Draw a ball and hang a simple, appropriate face shape from it. Note the positions for the angle views. Careful positioning of the jawline in front of the ear establishes the angle.

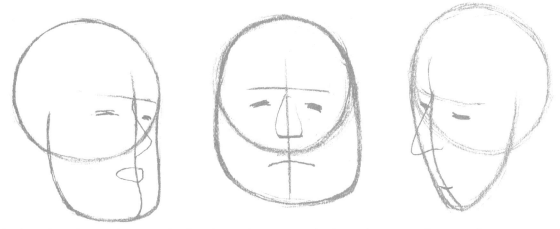

Add a brow line along with a properly placed centerline. Notice that both of these lines follow the form on which they sit, and determine the tilt and angle of the head. The solidity of the head is also now very apparent.

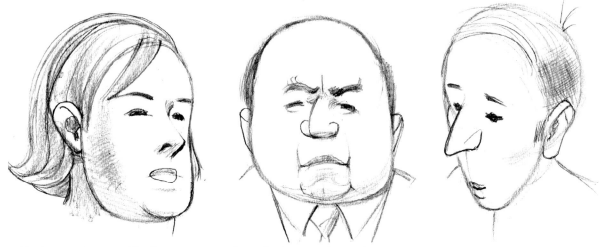

Add whatever degree of finish you want. But keep the features ultrasimple. We are more interested here in the big shapes and forms of the face, and in the placement of the features.

THE CHARACTER IS IN THE SHAPES AND FORMS

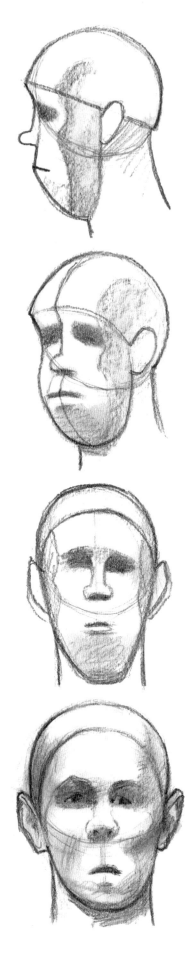

Here is an exaggerated character study of a specific type of head, still using our system without a model. There are several points to notice in this drawing. I started with a side view to visualize things more easily. Then I carried the profile line into the angled view to help with the visualization of that. Note the strong sense of solidity in these drawings. That's because I emphasized the separation of the side planes from the front ones. I also used simple tones to set back the chin and eye planes. Note also that there are no actual eyes, and the other features are indicated very simply with no detail—yet the character of this head is fully realized.

By thinking structurally this way, you can build any type of character into your heads, and avoid the deadly sameness that tends to creep into faces and heads drawn without models. Below is a more realistically proportioned head with the same basic characteristics as the head above. There are still exaggerations such as the low placement of the mouth, but the proportions are now in the believable range. I'm sure you can see the value in this kind of study for portraiture now.

Spend plenty of time on these caricature studies. Concentrate on the big, simple forms to build a solid structure to your drawings. There might be times when you're tempted to get a little more detail in your drawings, but don't put in more than I have here. Note how the eyes were handled. There is simply a spot to indicate the iris, a line where dark lashes might be, and a dot for the inside corner, but no outlines. And note the simplicity of the nose; it is practically symbolic. Another thing to take note of here is the underlying skull. Can you see it?

The facing page has three more characters done in this way. The bottom one is a good example of the importance of understanding the planar structure to accent the character in certain types.

This is not quite the simple project it seems at first. Some heads yield their structural secrets to you very reluctantly. Females and young people require a practiced eye to sort things out. But the very act of struggling with it will help you tremendously in the long run.

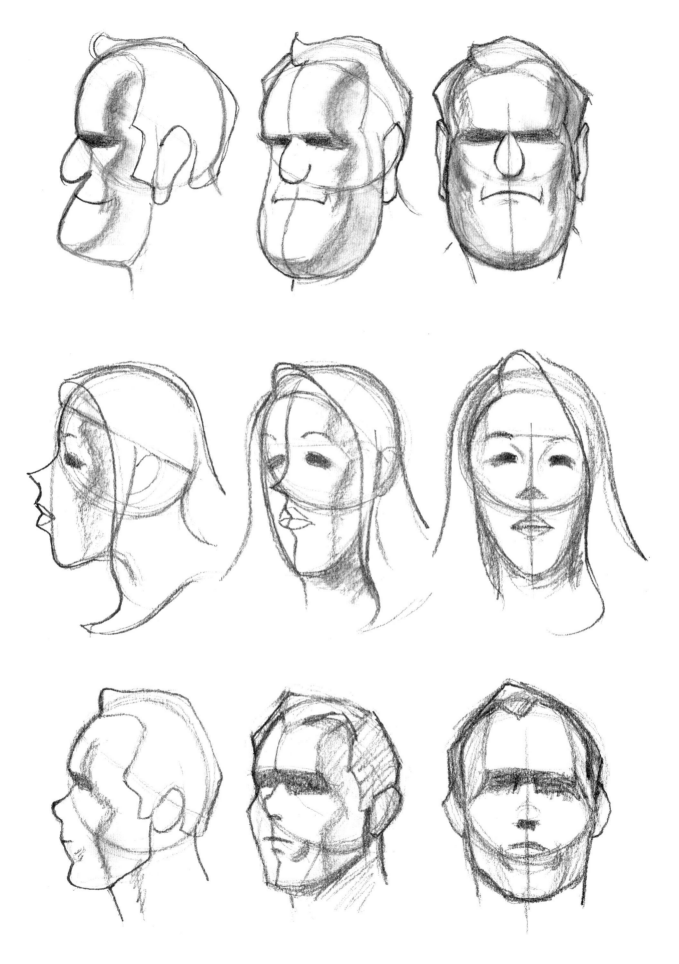

THE ALL-IMPORTANT SHAPE

If you're in the habit of skimming through books, stop here.

This is where everything has been leading. So please, get a clear understanding of what I am saying here; this is the secret to professional drawing. I consider the shape factor in drawing so important that I wrote a whole book on it, and still only barely touched on its possibilities.

From here on we drop the use of balls or ovals to start drawing. They were fine for learning proportions and to get you started, but it's time to put them behind us. At the beginning of the book, I explained the difference between forms and shapes. Now you will see why I consider that difference crucial. As artists, we think we understand what the word shape means—and in a superficial way, we do, and of course that's the problem. We simply don't give it much thought. The understanding and control of shapes is the difference between the master and the student. After all, everything you draw is dependent on its shape. That's all you have to work with, since you're working on a flat surface. You must reduce everything to a flat shape before you can do anything else with it.

Magically, the shape carries the essence of things. If you get it right, it will amplify the character of your model. If you get it wrong, it will destroy it, and no amount of polishing up later can save it.

You should have enjoyed your work with caricatures on the previous pages. You were working on the line between starting with flat shapes and three-dimensional forms. From here on we start right out with expressive shapes. We will consciously consider shapes and forms separately, to give you better control over both of them.

You cannot see both the form and the shape of an object at the same time. You don't draw actual forms; you only suggest them after you get the shapes in. If you draw the shape right, the form will begin to manifest itself, and you help it along. The whole trick to getting this right is to visualize the flat shape *before* you draw it. This is a very important distinction because so many books and teachers tell you to look for the solid form too soon, and that only makes it harder to draw accurately. Of course you need a strong sense of the fully rounded, solid form, and will be constantly switching your focus between these two states, but that comes easily when the shapes are right in the first place. If you concentrate on the form at the expense of the shape, you get confusion. This is where most drawing problems originate. The shape contains the form, and if the shape is right, the form follows easily. The two modes of seeing work together, but since you're working on a flat surface, you must consider the flat aspect (shape) of an object before you can get the form into it.

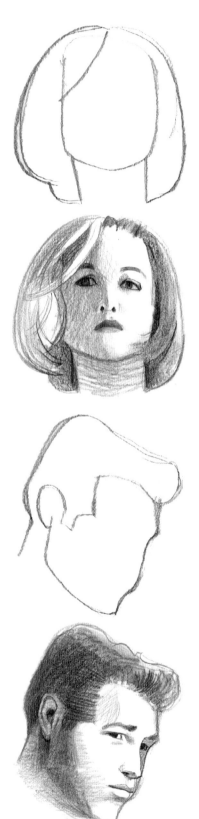

Magazines are an endless source for practice material. The drawings to the right were made from pictures I found in one. I looked at the subject only long enough to get an impression of the two big main shapes: face and hair. I then took no more than a few seconds to put that combination of shapes down the way they impressed me. A simple outline of the flat shape was what I was after.

Without altering the shapes I drew in the least, I then took a couple of minutes to place the features and put in some simple tones. The drawings above each face are the original outlines that I started with. There are many things about each drawing that I would change if I really wanted to finish them properly; still, something happened in the transposition of these shapes to the paper that shows their power to convey character and likeness, even if they aren't mechanically accurate.

KEEP LOOSE

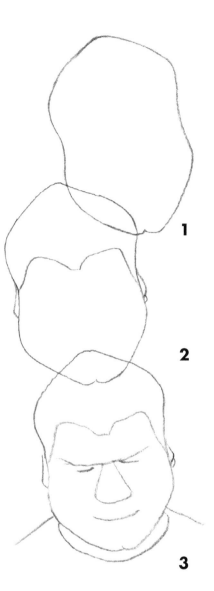

1

2

3

Try this experiment to see what happens when you look for simple shapes, and the right positions of the feature masses. Take any photograph of a head. The quality doesn't matter as long as you find it an interesting face, with some character in it. It can be at any angle you want. This one was taken at a local fair with my digital camera. It was cropped out of a much bigger picture.

Let the shapes in the photograph influence you, but don't try to get them exact, simply draw a big, simple overall shape of the whole head with approximately right shape and proportions (see drawing 1 on this page).

Now break it up into two shapes, using the photograph as your guide (drawing 2). Don't even concern yourself if they're slightly lopsided. Very lightly spot in the features in their relative positions. Check your drawing against the photograph—not for accuracy, but to see if you have things placed so that they "feel" right (see drawing 3). Finally, finish your drawing about like number 4. Don't get too fussy with it; keep it simple.

After you do enough of these, you should begin to loosen up, and your drawings will begin to take on a likeness to the face in the photograph that you can't get when you try to accurately copy it.

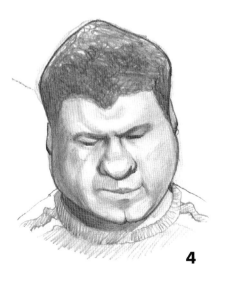

4

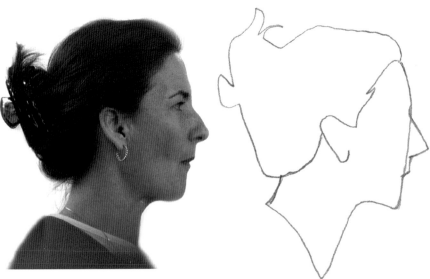

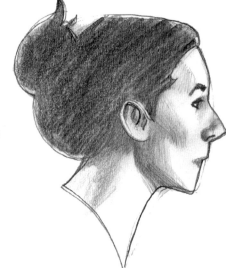

BACK TO THE PROFILE

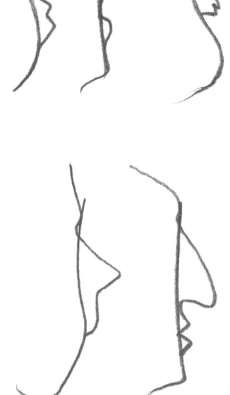

Remember the facial line I showed you in the beginning of this chapter? This is an indispensable tool when you're analyzing a profile view, which you should do before you tackle a serious portrait in any view.

Imagine a straight line running from the brow line to the chin, and draw it in. This is usually the first line I draw for a profile view. It establishes the tilt of the head, as well as giving me a base to work from when looking for the exact placement of the vital features in this view. I now simply determine if the forehead tips back, tilts forward, or continues in line with this baseline. I can easily see whether the bridge of the nose between the eyes dips in behind this line, or lines up with it. The direction of the nose in relation to the line is easy to see, as is the position of the lip mass. Once these points are established, you have an accurate profile of the sitter.

Above is a photograph of a good profile with a slight but distinctive characteristic that might be hard to notice if you were drawing a front view. But once you see it, you would find it easier to capture her likeness from any view. The facial line shows her lower lip in line with her chin, and it sits back from the line while her upper lip is in front of it. This would be hard to notice from a front view, but once you know it's there, you can portray it more clearly even when you draw her from the front. My little sketch isn't very accurate, but it still captures her essence, and could easily be made into a portrait if I wanted.

Below are some examples using exaggerated curved facial lines to work from. This helps to amplify the character if you get the curve right.

THE EVOLUTION OF A SHAPE

You want to be prepared for anything when you have a caricature of yourself done. You'd better put your ego in the closet.

This is me, taken from the photo at the front of this book. Ever since I started shaving my head, I pictured my face as being a block topped off with a shiny dome. This gave me my departure point for this experiment.

I started out with a flat shape reminiscent of this conception of myself, intending to develop it by using symbols for the features. I gave up almost immediately because I had no outstanding features that suggested anything to me. Finally, I decided that the only chance I had to get anything would be to work more realistically. The head on this page is the result. I started with the same shape in both attempts, but the basic shape dictated the realistic approach to me.

This should give you an idea of the power of a simple flat shape to suggest things. If the shape carries the essence, it practically dictates the best way to develop it, but if it doesn't have this essence it's useless to take your drawing any farther.

This particular shape, with its squared-off bottom, immediately suggested a solid form so it practically did my work for me as I developed it. Most shapes are not that cooperative, and usually need a few more clues before they look solid. Compare the blank shape on this page with the two starting shapes on the facing page to get an idea of what I mean.

When you look at someone, a combination of things adds up to create an instant visual impression. The overall shape of the head is usually a major factor; then the combination of shapes made by the face and hair become important. Finally the little things, like the peculiar shapes of eyes, eyebrows, nose, or mouth, enter in. This, of course, is a bit simplistic, because certain features can be so outstanding and dramatic that they stand out strongly before all others. A face that has such strong peculiarities is much easier to caricature or make a portrait of than one that's basically average.

EXAMPLES

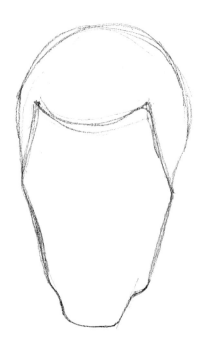

On this page are two widely different ways to finish the exaggerated shapes you find in heads. As before, both drawings were made from pictures in magazines. The simple shapes were taken directly from the actual shapes I started with. They were simply made darker so they would reproduce more clearly. These initial shapes were done in about one minute, and left practically as they were except for a slight change to one cheek line on the top face.

The top head was finished realistically, and except for strongly lengthening his whole head and face, it could be considered a portrait, because these simple shapes really caught the essence of his head.

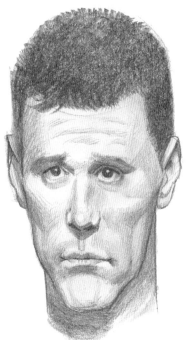

The bottom picture was finished using symbols for features. Any student of Native American history will immediately recognize this face. He is Geronimo, and he had such a powerful essence that you could hardly miss capturing it. His features begged for this symbolic treatment. Faces like this are a joy to caricature.

These are two extremes; there are a thousand more ways to develop these shapes. Try drawing the heads on this page by looking for big the shapes that impress you, and quickly putting them down first. Don't copy these drawings; simply look for the big shapes like the blank shapes on the previous page, and put down your impression. Then finish with the smaller details. Usually two big shapes hit

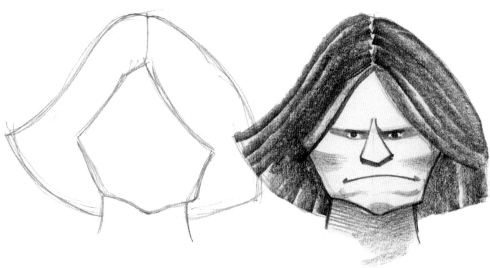

you first; the shape of the hair and that of the face. Sometimes it's the overall shape of the head that you see first. At other times it might be an unusual feature like a big forehead or nose that stands out. Whatever it is, get it down quickly and simply, then build from there. Note that many of the features on these drawings are symbolic. Think of them as shapes that need to fit in the right position.

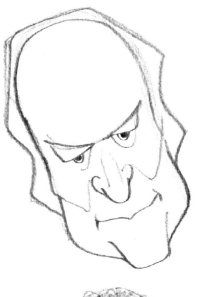

After you finish drawing these, and you feel you can see the underlying shapes well enough, start drawing from pictures in magazines, newspapers, or, better yet, real life. Draw with the same attitude: It really doesn't matter whether it's recognizable or not, as long as it captures the character.

The big difference between this and the last exercise is that you're now working with pure shapes; you have no preconceived semisolid shapes, like the ball or oval, to get you started. The shapes you are working with should have the essence of your subject built right into them. Surprisingly, even though you thought of them as flat shapes, when you draw them in, they quickly begin to take on a solid form as you add details inside them. This is probably contrary to everything you might have learned about drawing in the past. Of course the details have to be in the right places, but the shape will guide you if you let it. The big lesson here is—learn to see the shapes in things as flat before you draw them in. It helps to squint when you look at your subject. After you got the shape you want, you can push the sense of solidity to any degree you want easily. I'll show you how in chapter 6.

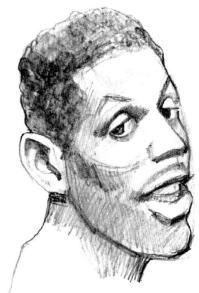

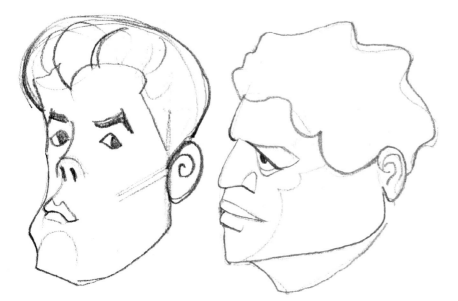

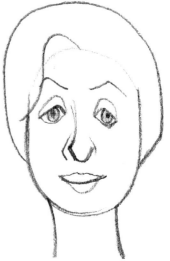

CHAPTER FIVE SYMBOLISM

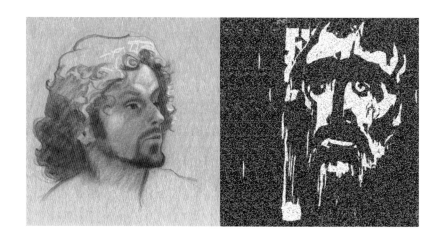

Symbolism offers us a powerful tool for heightening the emotional response to our drawings.

SYMBOLISM

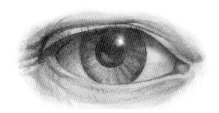

Drawing is a natural language. You read and interpret the lines, marks, tones, and colors on paper just as you read this typed page. Basically, most of the people of the world interpret the marks made by artists in the same way. As long as they're based on reality, the language is universal and can be understood by everyone, everywhere.

Symbols are shapes or patterns that strongly suggest things to us. It's only when we stray from reality deeper into the world of abstraction that the language can get fuzzy, eventually to become unreadable. This area between reality and abstraction is what modernists are exploring, occasionally with brilliant results.

Art, as I see it, is a combination of symbolism and realism. Of course I know that it's all symbolic, but I have to stretch the point in order to get my thoughts across here. No doubt some of you caught my questionable use of symbolism in the introduction of this book. Bear with me, and I'm sure you'll see why I use the word as I do.

Our brain accepts things symbolically. Through eons of conditioning, we have learned to accept shapes and patterns fully as to completely blur the line between the way things actually look and the symbolic representation of them in art.

On one end of the art spectrum we have realism. This is the depiction of things—with all their shapes, tones, and colors—the way they actually look to the eye. On the other end we have shapes, tones, and colors arranged in a way that brings these things to mind. When art falls outside this spectrum, it no longer communicates with us.

Let's consider an eye. There is a practically unlimited number of ways to depict an eye. The illustrations here show four ways of doing it.

This drawing is based mostly on the way an eye actually looks to us. Although it is symbolic, it has the least symbolism of the four. Most people all over the world could readily understand it.

Less realistic, and more symbolic. This is a shape that most people would recognize as an eye.

The third drawing is still more symbolic and less realistic, yet, there's still something about the arrangement of the shapes that suggests an eye. We have also been conditioned through cartoon characters to accept this as representing an eye.

This could be many things. If there were two of them, or if it was inside a shape that suggested a head, it might be recognized as an eye. As is, however, it really needs more clues to do the job of suggesting an eye. It has the least realism.

The features of the face can be symbolized easily in so many ways that only your imagination can limit them. These symbolic representations can often be more powerful than any realistic depiction. Think of a snowman with a carrot for a nose, and coals for eyes and a mouth, to get an idea of the power of suggestion of strategically placed abstract elements in the proper shape.

Not only the features but also the shape of the head, face, or hair can be drawn symbolically to more strongly suggest the person you are drawing. By emphasizing the size, shape, and relationship of things, we can get more powerful emotional responses from our viewers than if we were to merely copy them.

At the bottom of this page you'll find a few symbols of eyes, hair, mouths, noses, and ears. You will also find "Kilroy"—one of the most famous symbolic figures of World War II.

The drawing at top right is a purely symbolic representation of an actual person, drawn several weeks after I saw him. I didn't think about drawing him when I saw him, so my memory of his features is probably faulty. His overall head was egg shaped and slightly lopsided. His features were placed more closely together than normal. His nose was short and broad at the bridge; his hair was patchy, long, and reaching out in many directions. He had a very distinctive patch of hair under his lower lip. But it all added up to a very pleasant face. I chose to draw all of these things symbolically, without any concern for reality. Sometimes these drawings will amaze you by their strong suggestion of the model. After you work this way for a while, you develop a sense of the essence of a person, and if you apply this sense as you attempt more realistic portraiture, you will find that likenesses come more easily.

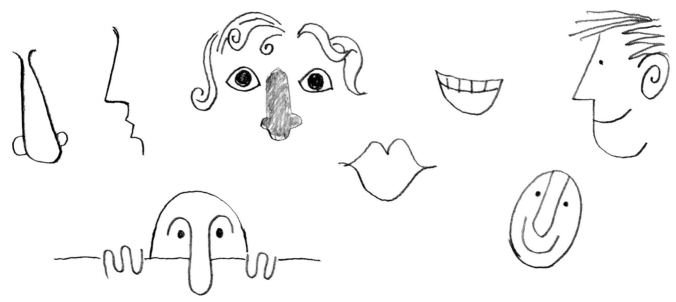

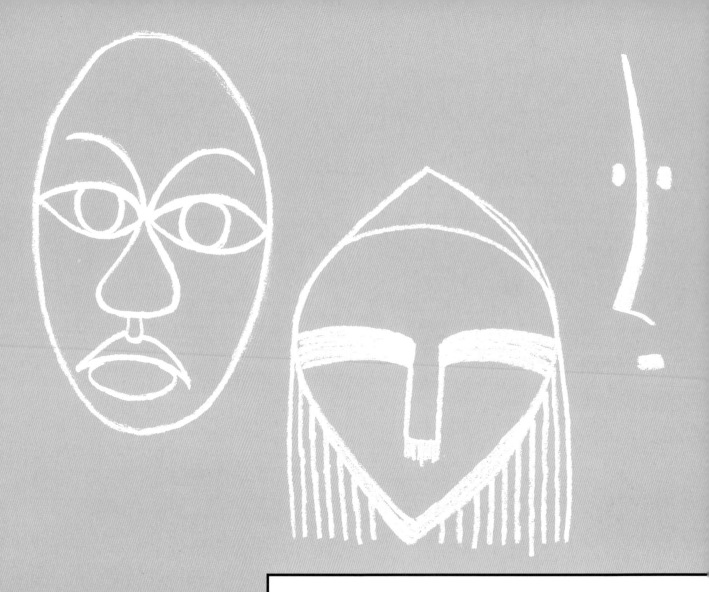

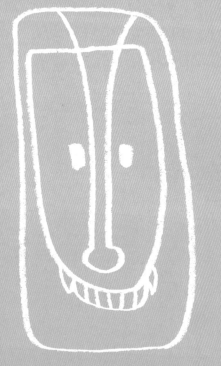

THROUGH THE AGES

Symbolism has been used by every culture through history. From the ancient art of hieroglyphics and the symbols found on rocks and in caves, to many of today's artists, we find a rich source of incredibly imaginative and expressive work.

As you go back through the ages, you will find the human head and face depicted symbolically in so many ways that it seems we will never run out of new ones. Yet there's a common thread running through them, and it's often startling to find strong similarities between cultures that could not possibly have had any exposure to each other.

On these two pages are sketches done after looking through a book on ancient art. I simply absorbed the feelings I received while looking through the book, then let the pictures flow out as I remembered them. They are partly imaginative, and partly how I remembered what I saw. To me, they have a strange emotional quality that I would never get from realistic drawings.

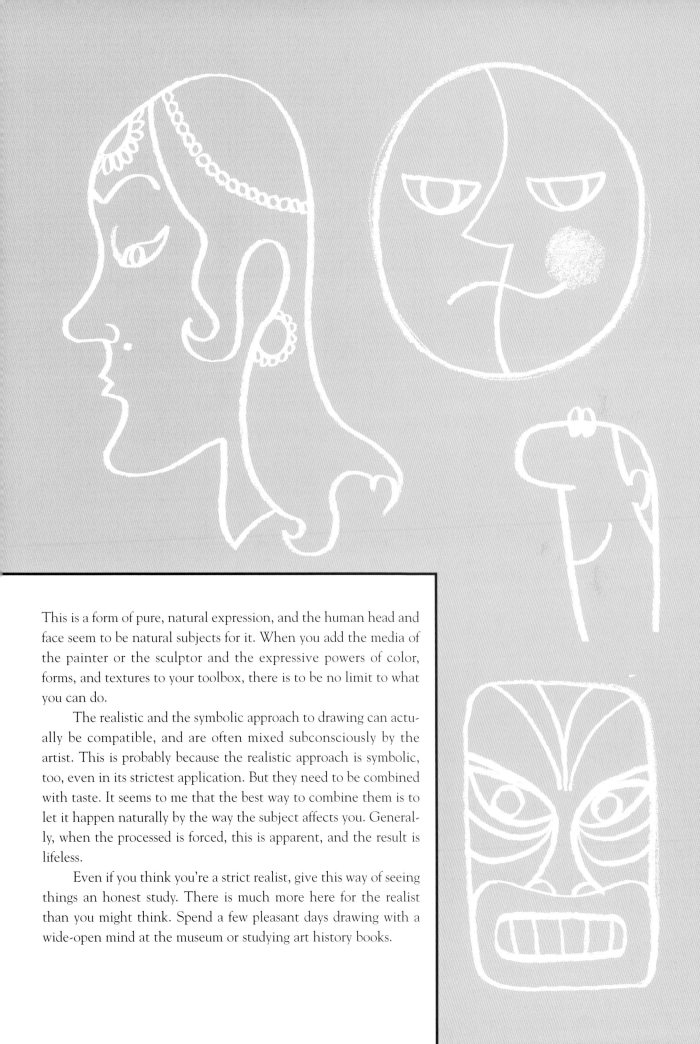

This is a form of pure, natural expression, and the human head and face seem to be natural subjects for it. When you add the media of the painter or the sculptor and the expressive powers of color, forms, and textures to your toolbox, there is to be no limit to what you can do.

The realistic and the symbolic approach to drawing can actually be compatible, and are often mixed subconsciously by the artist. This is probably because the realistic approach is symbolic, too, even in its strictest application. But they need to be combined with taste. It seems to me that the best way to combine them is to let it happen naturally by the way the subject affects you. Generally, when the processed is forced, this is apparent, and the result is lifeless.

Even if you think you're a strict realist, give this way of seeing things an honest study. There is much more here for the realist than you might think. Spend a few pleasant days drawing with a wide-open mind at the museum or studying art history books.

THE SEARCH FOR PURE EXPRESSION

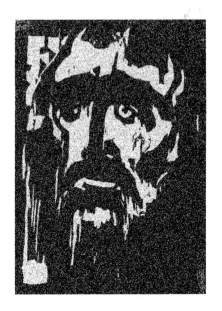

There are no doubt all levels of experience and accomplishment among the readers of this book. Most of you will simply wish to be able to draw passable heads and faces, but some will want to go much deeper. This chapter is for them.

The examples on these pages are there to show you that there is a much wider range of expression open to the serious artist than simply copying what you see. When you understand how lines, shapes, values, and colors speak, you begin to appreciate these seemingly crude attempts at portraying the human face. After you have drawn as long as I have, you can no longer overlook the power some of these works have to stir the emotions.

This kind of art is very personal and would be difficult, if not impossible, to teach. Since my own inclinations lean toward the more traditional approach, I intend to stick with the thi ngs I know something about, and simply tell you to follow your own drummer. In any event, you will still need the basics before you can do any meaningful exploration.

The artists who did the work copied here were all grounded in the basic fundamentals that we discuss in this book. All reached the point where they felt the need to reach beyond traditional ways of expression. Their works are the result of their search to portray the essence of their subjects in a more powerful way. If you go back to the opening of this chapter, you will see the drawing below next to a more realistic drawing of a head. Note your different emotional reactions to each of them. These are widely different techniques, and of course there are any number of approaches in between for you to explore, so don't limit yourself to one way of thinking, especially until you've had enough experience to know yourself.

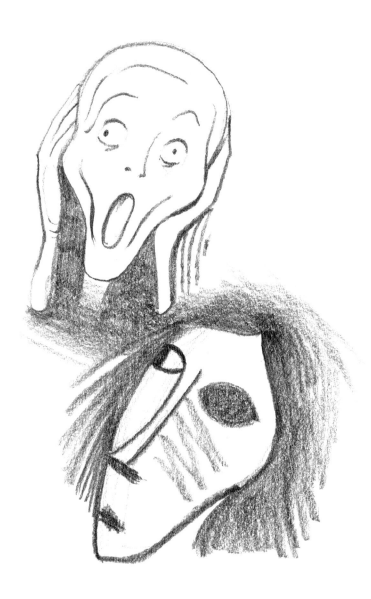

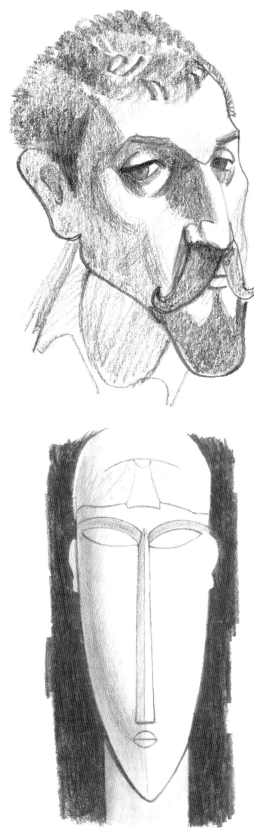

Here are some examples of how symbolism, along with the use of shapes, work to heighten the dramatic, emotional response to images. These are quick sketches of well-known masterpieces of modern art. They are inaccurate copies, and were simply made to demonstrate these points. Much of their impact depends on their color and broad, simple brushstrokes, both of which are absent here.

Books on art history are full of such examples. I recommend that you try looking at them with an open mind for a while before you decide whether you want to pursue this direction or not. Many young artists take this road because it looks easier. But those who have seriously tried know better. I would bet that the copy of Paul Gauguin's self-portrait has more of his true essence than a photographically rendered portrait could ever have.

CHAPTER SIX VALUES

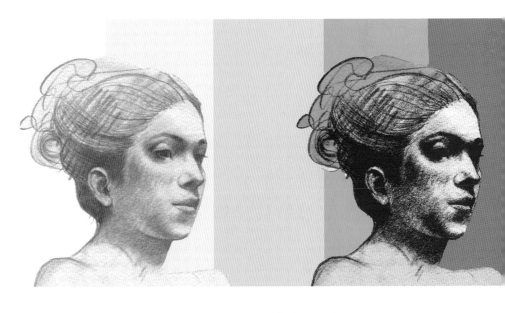

Values are your most powerful tool
for getting things to look solid.

VALUES

One of the most powerful tools you have to get form and solidity in your drawings is the range of tones between black and white. These are called values, and the way you use them can determine the success or failure of your drawing.

We can make the flat shapes we draw look like beautifully rounded solid forms. We can make them glow with a sense of light. We can make them somber and moody, or light, and happy, all because of the way we control the values.

By now I'm expecting that you are using the conté crayon and soft pencil that I recommended earlier. Later, you can try other media, but this is enough for now. It's time to really get control over these two media. You should be able to control the placement of lines pretty well, but let's begin to concentrate on controlling the pressure as you draw to create lines and tones of precise values. It also might be time to add a harder pencil to help you with your lighter tones. An HB or even a 2H will work just fine.

THE SCALE

Take a look at the column of values on the far right. They go from pure black to the whitest white we can get, which is our clean paper. There are approximately thirty-four levels of gray before it melts into a single pool of black in the reproduction I am looking at now. The one you are looking at will probably be less distinct, because it has been printed with halftone dots. This column becomes almost a

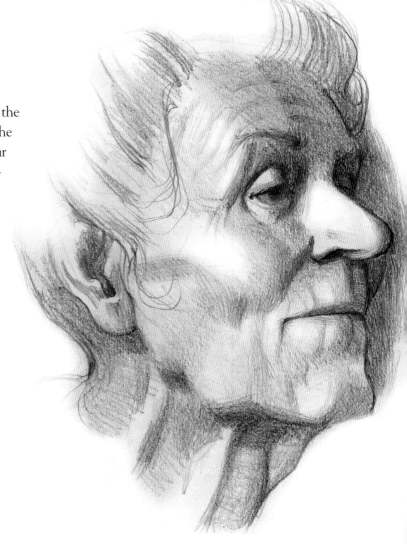

Values are responsible for the sense of solidity in this study made from a news photo in a magazine—an excellent source for studying heads and faces of all types. Note the form of the skull and the strong planar structure, which is always apparent in older people.

smooth blend from black to white. It would be an exercise in futility to try to match them all with your crayon or pencil. Even if you could do it (and you couldn't), there would be no point. All you can do is make about ten values that are different enough from each other to be distinct.

Try this experiment. Starting with the lightest even tone possible, make a rough rectangle of approximately one by two inches. Then make another one adjoining it that is slightly but clearly darker. Keep working darker until you hit black, or the darkest tone you can make.

Here is what you just learned. You probably only got around six or seven values, but you might get to ten, which is about the limit of what you can make and still see a clear difference between all of them. The conté crayon will give you a deeper black, but it's slightly harder to control in the lighter values. The pencil—assuming you're using a softer grade—will not let you get quite as black, but it will give you somewhat better control when making the light values. You could always get a harder stick of conté to help you with the lighter values, but most stores do not carry the different grades. Graphite pencils are also available in different grades, and the harder ones will give you even lighter values. But there really is no point in getting that technical right now. I want you to stick to approximately five values plus the white of your paper. This will give you a clearer separation of tones, and your work will be far stronger because of it.

Here's how you arrive at your five values. Make five light squares in a row on your paper. Start at one end with the lightest gray you can see against the white of the paper, and put in your blackest tone at the other end of your row. Fill in the center square with a middle gray that seems to belong right in the center between these two extremes. You may need to adjust it lighter or darker until it looks right. Finally, do the same thing in the remaining two squares by creating grays that appear to fit neutrally between the existing tones on either side of them. After you finish, step back and look at your work to see that there are no great jumps in value from one square to the next. If there are, adjust the offending squares until you get a smooth transition in the whole thing.

You occasionally want softer, more subtle effects than you can get with these five values when you're making finished drawings, but these are all you need for most of what we'll be doing here. Your drawings will be much clearer and stronger by sticking with the five, and when you soften the edges as they come together, there should be no need for more anyway. Now you have only five values to look for: a light, a dark, a middle, a light middle, and a dark middle. I don't mean that you need to memorize five specific values; rather, your full range should be divided into roughly five evenly spaced values, giving you better clarity between each step. You cannot make it any simpler without posterizing things.

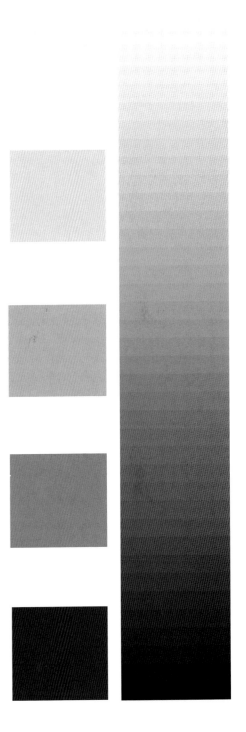

LIMITING VALUES

I could have put the study of values among the basics at the beginning of this book, but I felt that it was important to get you drawing as quickly as possible. I think you'll now be able to understand the importance of this subject much better than if I had placed it in earlier.

If you are to convince anyone that the flat, outlined shapes on your paper are solid, fully rounded forms, you're going to have to understand and get control of your values. Lines are very important as well, but when drawing the head as described here, values take the top position.

You have learned that your tools have certain limitations in producing values. Now work on controlling your hand pressure as you draw so that you can get the exact value you want. This is reasonably easy to do, and shouldn't take much time to accomplish. We are then going to learn how to make these values work in order to get the effects we're after.

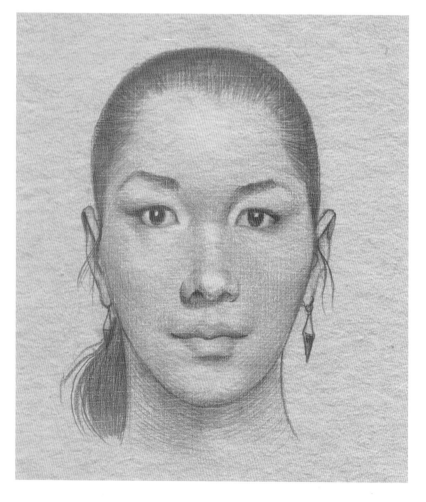

This picture was done from imagination using the basic map as a starting point. It was practically finished using only five flat values. It then needed only a simple softening of the edges of some of these areas of value, and working between them with additional tones where needed. These five basic values gave me a perfect framework to judge these additions against, and gave the drawing great solidity. Young faces such as this require great control over your values, and limiting them in the beginning is the best way to keep from muddying up your flesh tones as you finish your drawing. Most of the time it's best to leave the five values do the job with a limited amount of finishing. But this demonstration shows that you can expand them if necessary. Note that I limited my value choices even more by using it on a gray background. I could use white to raise my upper limits, but highlights on a soft feminine face usually ruin it.

PLANES

Describing and illustrating the use of planes is extremely difficult, since it's even more intuitive than many of the other factors involved in the drawing process.

For our purposes, a *plane* is an area of a rounded surface that has been slightly flattened in order to better show the structure of an object. Drawing 1 reveals how the boundaries of planes are arrived at. It shows the contour of a rounded surface. There are no truly circular curves anywhere in the human form, and unless you have a perfectly circular segment, it will have places where it curves more sharply. The segments that fall between these high spots can be seen as flat surfaces, as we see in drawing 2. The apex that is formed by the meeting of these two lines leaves an edge as they come together inside the contour, and can be shown by a line or sharp change of tone. Drawing (3) to the right shows these lines as they might occur on this particular head.

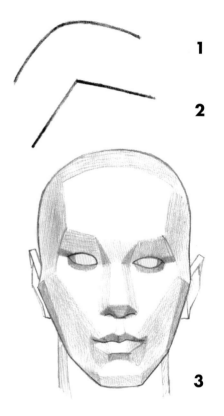

The ability to see the planes in your subject will help you immeasurably in your rendering of tones. It will also help in the actual drawing process, and will give you another powerful tool for capturing and emphasizing the character of a particular head. You will probably never need to carry anything as far as I've taken drawing 3, because it passes the point where it begins to look contrived. However, when you begin to look for these things on your model, you will see areas that cry for simplification. Heed this cry. Eventually you won't even need to consciously look for these things; they become a part of your own personal way of seeing things, and your work will take on added power.

You have already had some experience with flattening the sides of your mapped head. The best use of this concept is to "square up" your heads as you lay them in, reducing everything to either a front, side, or back plane. Look for that line that separates things that seem to belong to the front plane, and those that belong to the side planes, and draw it in carefully (see drawing 4). Notice the solid feeling that this gives to the head, even though the planes are treated flatly. If you were to carefully soften a few well-chosen edges, nothing else would be needed to finish this drawing.

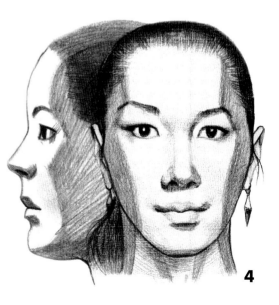

This squaring-up process really helps you place the features solidly in their correct positions, as well as to see your whole drawing as a solid unit. Spend enough time on this to make it work for you. You'll be happy you did.

BACK TO VALUES

Imagine you had to match each of the thirty-four values every time you drew. That would certainly limit the number of people who learned to draw!

Fortunately, thinking in five values not only simplifies things, but actually improves them. It adds clarity and power to your work. To make things even better, you normally don't even need to be very accurate with them. I read a book a few years back that insisted you not only learn to make and number a ten-value chart, but memorize the values so well that you could recognize and number them when you looked at things in nature. Pure nonsense! First, the eye doesn't work that way, and second, values are relative. Also, the value range in nature is much broader than ours on paper. You are simply concerned with your lightest light, which is usually your paper; your darkest dark, which is rarely a true black; and the steps between those two extremes. A reasonably smooth transition of grays from one to the other is all that's possible. Limiting these grays to four along with the white of your paper gives you much more leeway and control than does filling your head with useless information about memorizing microscopic changes in values. You need only decide if the value is light or dark, and how it compares with the values next to it. If you can't decide whether to classify it as light or dark, it's probably your middle tone. Finally, even if you have a model in front of you, the important thing is how your values interact on your paper. In the end the model will be gone, and the drawing is the only thing left to look at.

This doesn't mean you can be haphazard in your use of values. Quite the opposite: It gives you better control over them. You still need to practice controlling your hand pressure to the degree that you can create the slightest change between the values on your paper that is visible. Once you get five reasonably controlled values down, you will usually be happy with the result. But if you aren't, you can adjust them any way you want, or add values between them, and soften edges as much as you feel necessary without losing control over them.

Values can also be used to create or heighten moods. Overall dark values usually are more somber or threatening. Lighter values are generally happier and optimistic. Contrasting values can suggest effort, or even violence or strength. Middle values might suggest serenity. You can compress your value range even farther, by limiting yourself at either end and eliminating the black or white—thereby heightening the mood. Be conscious of the overall value scheme of your drawing. You can make it work to add emotion and mood. This information can be invaluable when creating a portrait.

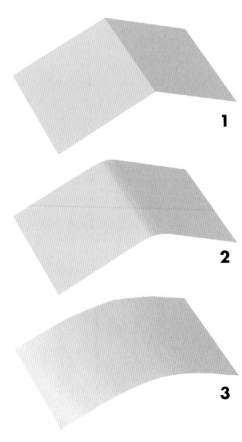

1

2

3

You use values to create a feeling of solidity and reality in your drawings. An area of light value will seem to turn back into your paper, or go back in space, as you add even a slightly darker tone into it. If the edge where these two tones meet is hard (drawing 1), it will seem to turn sharply. If the edge is softened (drawings 2 and 3), it will seem more rounded, depending on how far the tones blend into each other.

MODELING THE SURFACE

There are several ways to make things look rounded or solid when you draw. Here are two of the most commonly used ways using tones, or values. Drawing 1 was made by swinging my pencil around the perimeter of a circle. I bore down to make the outside of the circle dark, and lightened up my pressure as I approached the center to make it lighter, leaving a white center. You can see the effect of a solid ball here.

To make this illusion work, you need to sense the surface turning back as you darken it. You are sculpting the form with tone. Note that the part that seems closest to you is near the center, where the ball is the lightest, and at right angles to your eye. It turns back slightly as it gets darker until it is farthest away from you, where it's the darkest. It also darkens because the angle of the surface is becoming more acute as it gets nearer the perimeter.

In the second illustration I pushed the light area off to the side and carried the blended tone clear to the perimeter before it became its darkest shade, just as I did before. This is a common and natural approach, and it still suggests the form, but it actually creates an unnatural situation and will give you trouble realizing some forms.

Both of these approaches seem to come naturally to us, and are used regularly by artists when they work from imagination. They are often mistakenly used when an artist is attempting to emulate the true effect of light on an object. Approach 1 is more true to the actual way light would behave, since it suggests that the light is coming from the general direction of the viewer's eyes, and shadows would not be visible.

The third illustration is the true depiction of how light works. The lighted area continues to darken until the light cannot hit the surface anymore. Then the shadow begins. It's always darker than anything in the lighted area, but its darkest area is usually right at its beginning. From there on it lightens slightly, depending on the kind of light reflected back into it. Light always creates shadows—two separate areas with separate qualities that merge into each other in a distinct way. Shadows can range from a light middle value all the way to nearly black. The amount of modeling you can do in the light areas depends on how dark your shadows are, since there has to be a definite difference in value between the two areas. It's usually a good idea to push your shadows darker, so that you have more opportunities to model in your light areas. That way you can work with your full range of values and get more impact into your work. Obviously, there are exceptions; you might want a more limited range.

The last drawing is my planar example from a previous page. It shows how by simply darkening an area on an object—in this case, a head—it seems to turn back into the picture plane. If you were to blend these edges together softly, you would get a normally rounded, solid head. By starting out with the planes, you get more control of the values and can better hold together the character of the sitter. When you blend everything together too much, you lose this character, and end up with mush.

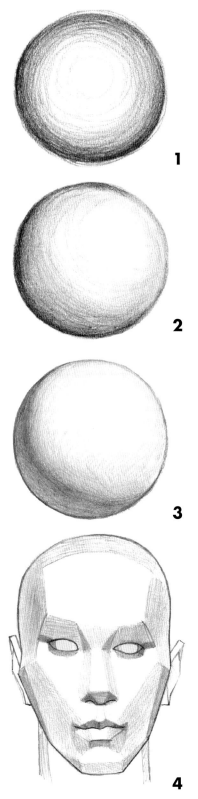

1

2

3

4

LIGHT

ight is the big factor when rendering form. There are many ways to get the effect of light falling on a solid object, but they are all dependent on one unbreakable law. Fortunately, it always works in a predictable way, and strong light effects can even be created from imagination if you clearly understand the forms you're rendering. Also, if you understand the other laws of light, you can stretch them to make your designs better. You wouldn't be breaking the laws; simply using them to make something look more like you want it to.

Since the primary light source cannot reach the shadow area, except by reflecting back into it, we have one big easy-to-understand law that takes precedence over everything, and that is the law of the separation of light areas from shadow areas. This law is so simple and so obvious that almost nobody gets it. Yes—you read that right. For reasons beyond my understanding, we all need a period of getting it wrong before the lightbulb goes on in our brains. Some of us never get it right.

Without a clear difference in value between the whole shadow area and the whole light area, it's impossible to get a true effect of light shining on anything. All the other things we will talk about here are useless without the first law being in effect. This means that on an object of a single color or value, such as a face, every tone in the light area has to be lighter than any tone in the shadow areas, period.

The interplay of light and shadows can turn an ordinary face into a thing of great beauty. Think of the perfect marriage between two completely different people—each with totally different qualities that augment the other and make the combination into something much more than either would be alone. That is the marriage of light and shadow on an object, giving it a beauty that it wouldn't have without each of them adding its particular qualities to the form.

The light area starts out with the area most squarely facing the light as the lightest. Often this is the white of the paper you are drawing on. It then gets progressively darker until it becomes as dark as the shadow. At that point it *becomes* the shadow, taking on all the shadow's qualities.

If the light source were an eye, everything it could see from its viewpoint would be in the light area. Anything it couldn't see would be in shadow. The lightness or darkness of the shadow depends on the ambient light that gets to it. Usually it's the light reflected into it from nearby objects. On a bright, sunny day, the light from the sky is often the determining factor in the value of the shadows. Sometimes, when there is no secondary source of light (such as in a dark room) and the

Here are some additional observations that will add to your success in depicting light:

- Unless you really have a legitimate reason, never use two light sources, the way photographers do. Keep your lighting simple, and use reflectors when shadows are too dark.

- Since they always receive less light, the shadow areas are softer and have softer edges than the areas in light. They will also have less detail.

- The overall darkness of the shadow area limits the range of tone you have to work with in your light areas. If you want the impact that you get from a full range of values, you have to force the shadows deeper than they look to you on the model.

- There are times when the basic shadow area is light enough to force you to keep your lights practically flat. You then have to soften the edges to help you keep things from looking too flat. Alternatively, you can deepen the shadows and model very delicately in the light areas. This requires a very sensitive touch to make everything flow smoothly over the whole form. An example of this will be found on the following page.

- The band of tone in the light just as it enters the shadow carries the whole story. It will be softer and wider on rounded surfaces, and harder as the surface turns more abruptly. If the object has texture, it will show more clearly there.

- Surfaces are lighter as they face the light, and get increasingly darker as the angle gets sharper. They are also lighter as they get closer to the light.

- Shadows almost always have softer edges than the lights at the contour of objects.

main source isn't too strong, the shadow areas will melt right into the pool of darkness that makes up the background and disappear.

The first image is a sphere with the light coming from our right, and slightly to its front. I have reduced it to five grays plus white and black for clarity. Four of the values are in light, and two in the shadow; the black is used only sparingly in the cast shadow. You need only blend the edges between values properly to get a perfectly rounded sphere. Right at the shadow's edge, you will find the penumbra (A); this is that mysterious band where the light and shadow blend—where light ends, and shadow begins. It practically carries the whole story of the form. You can actually eliminate the other three bands in the light and still create a sense of solid form. Note that when you squint at the drawing, this band still identifies with the light. When you properly darken its edge as it meets the shadow, though, it's less obvious.

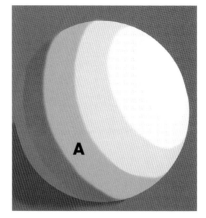

At right is a cross between a sphere and a cube. It's actually a twenty-six-sided figure derived from an octagon. This gives us flat planes facing in every direction for us to study. It's lit pretty much like the first sphere, but the light falls quite differently on it. Notice where the penumbra band falls now. It was right at that angle to the light where it couldn't decide whether it was light or shadow, so it photographed unnaturally dark. Note the square (B) directly below (A). It is actually now in shadow, but catches enough reflected light from the floor to confuse us. If we were to render this, we would lighten the penumbra to remove any doubt where it belonged.

The third picture shows how abruptly the light can turn into a dark shadow, and really emphasizes the fact that the shadow and the light are totally separate things, yet work together to form a complete whole. In this case the penumbra is missing because the forms turn too sharply from each other to make one.

Note the light triangle that tells us where the light is coming from. Now, the values in the light area do not get progressively darker here as they move from it. Instead, the value of each remaining square is determined by its angle to the light source.

In the final piece we have a different situation: The light is coming from behind the object, completely flattening the light area and leaving only the shadow and the contour to explain its shape. Notice that if you squint at it, the shadow becomes a simple flat shape. This is because the range of values in the shadow is so narrow. They lie somewhere between the two values shown below.

MODELING THE LIGHT AREAS

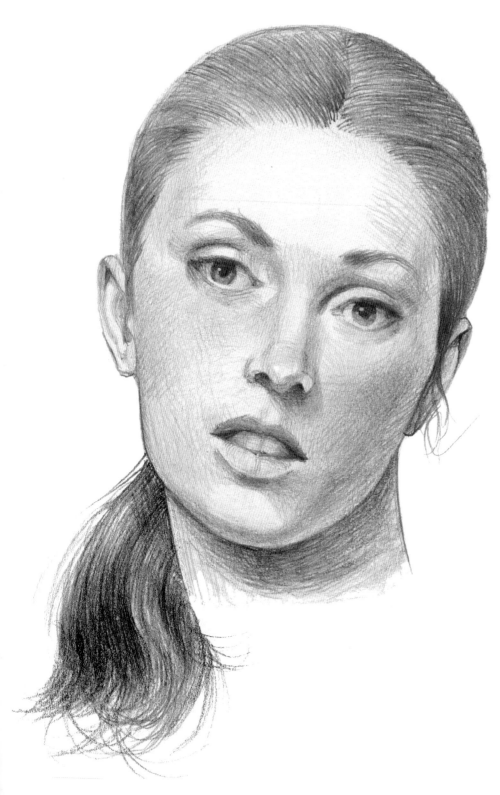

This is a pencil drawing made from a photograph of a fashion model. It's not a copy; in fact, it doesn't resemble the photo at all. My purpose was to demonstrate how you can use tones to force the sense of reality in your drawings. The photograph was a typical slick model shot with all the detail burned out of the light areas to smooth out her face. A pretty young woman is probably the biggest challenge you'll face when it comes to rendering skin tones. You'll always be more successful if you flatten out the major areas in light into a very light value, and use modeling only where the shadow begins. The light is coming from her upper right, so the shadow area begins on her left side (actually the right side as we look at it).

I rendered the shadow forms first; note how light and delicate these shadow areas are. Then I decided to get more form into the light areas than the photograph showed. This requires a very delicate touch since all the tones in these light areas have to be lighter than the already light shadows. I was forced to work in an extremely limited range, and changed to a harder 2H pencil for this.

The drawing is far more finished than I usually like to do, but it's an example of how far you can take your pencil drawings if you're so inclined.

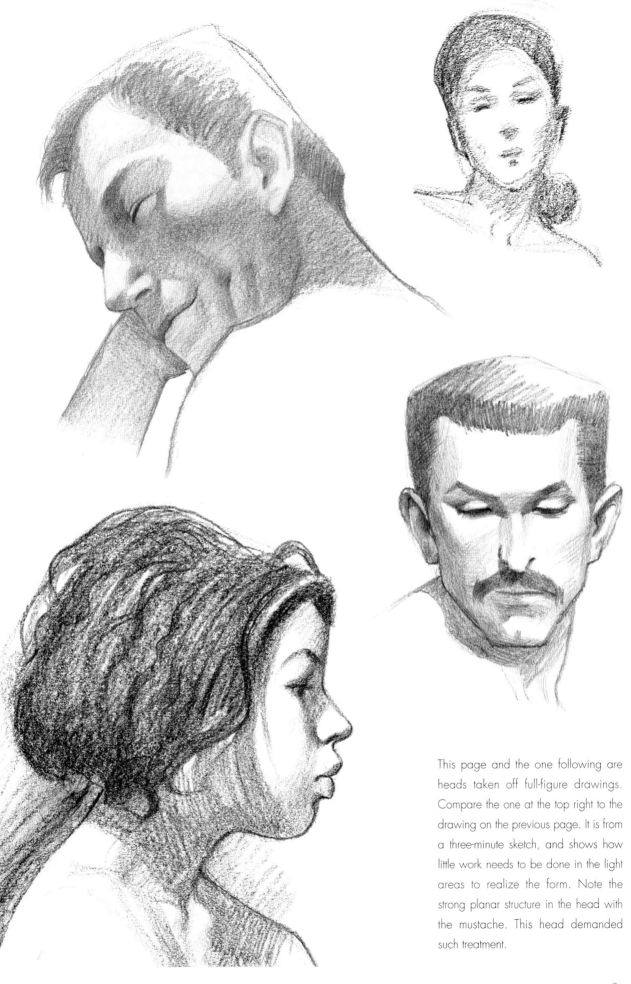

This page and the one following are heads taken off full-figure drawings. Compare the one at the top right to the drawing on the previous page. It is from a three-minute sketch, and shows how little work needs to be done in the light areas to realize the form. Note the strong planar structure in the head with the mustache. This head demanded such treatment.

MORE HEADS FROM FULL-FIGURE DRAWINGS

These drawings feature varying degrees of finish, and you can tell the ones that I labored over. They were all from poses of no more than one hour for the complete figure. All depend on the effect of light for their sense of solidity.

There is always a subtle difference in the final result when you work from a live model, and even though these are not portraits, they capture some of the character of the model. Such diversity in character would not be possible working purely from imagination. In addition, faked lighting would also be obvious to the trained eye.

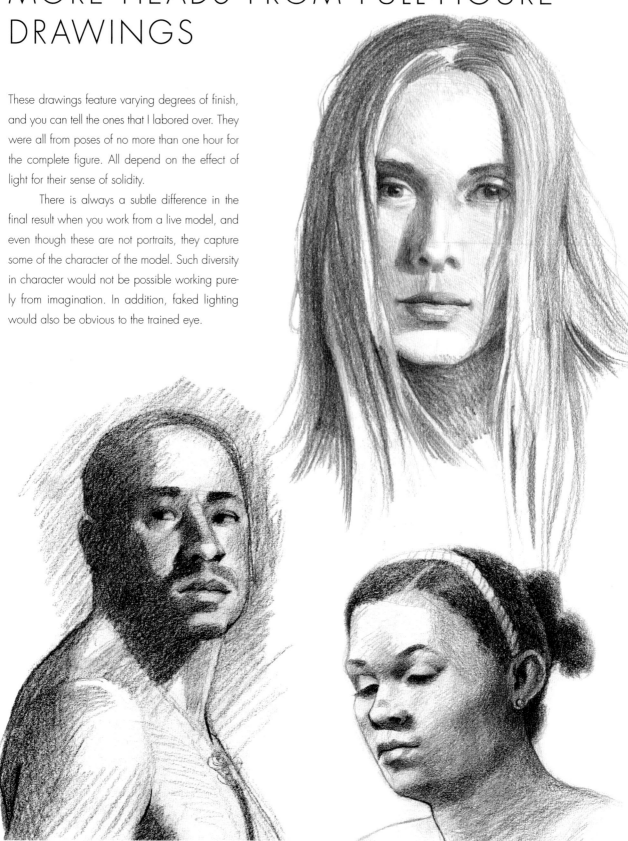

USING VALUES TO SEPARATE SHAPES

We've been tightening up in the last few chapters, and it's time to remind you of something you learned in the very first chapters in the book: If the big shapes are right, and the features properly placed within them, you don't need much in the way of detail.

Here we have a very low-quality digital photo taken with a ten-power zoom lens from across a little pond in a park. These are the very best type of photos to work from when you're studying shapes and values. It's almost the same effect as squinting at your subject. Notice how easy it is to see the shape of the face and hair mass. The little sketch next to the blurred photo has no detail at all. Everything was done with values. I pushed the contrast between values where I wanted it, and sharpened an edge or two, but I still simplified things even more than in the photograph.

In this sketch the values were used basically to separate the shapes from each other, and yet they also add to the feeling of three dimensions. This is probably a little loose for a main subject in a drawing or painting, but it would be ideal for secondary or background figures. It wouldn't take much to finish this little sketch. Never forget this simple structural way of blocking in your heads. It's much easier to figure out where a big blocky mass fits into the puzzle than it is to place sharp little details accurately.

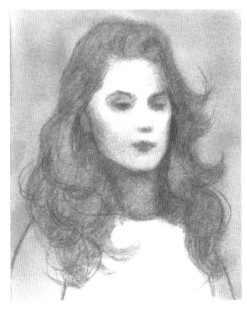

If you have a camera with a long lens, you will never run out of interesting characters to draw. Just sit in the park, or anywhere you can be unobserved, and wait for interesting subjects to show themselves. It's actually better if these shots are blurred or out of focus, or have to be blown up until you can see their pixels. That discourages copying, and emphasizes structural content. It also simplifies the values considerably. The only problem is that all the edges in an out-of-focus photograph are soft. Take this into consideration as you work, and sharpen them in a few logical places.

CHAPTER SEVEN
THE PORTRAIT

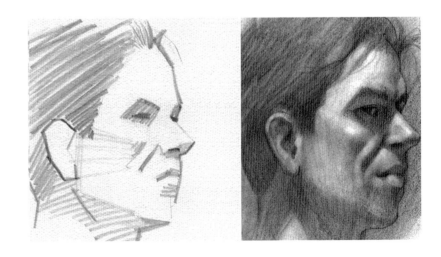

Portraits are not for everyone. Try your hand at this exacting art form and find out if you are one of the few artists who can excel at it. But be prepared for a big dose of frustration along the way.

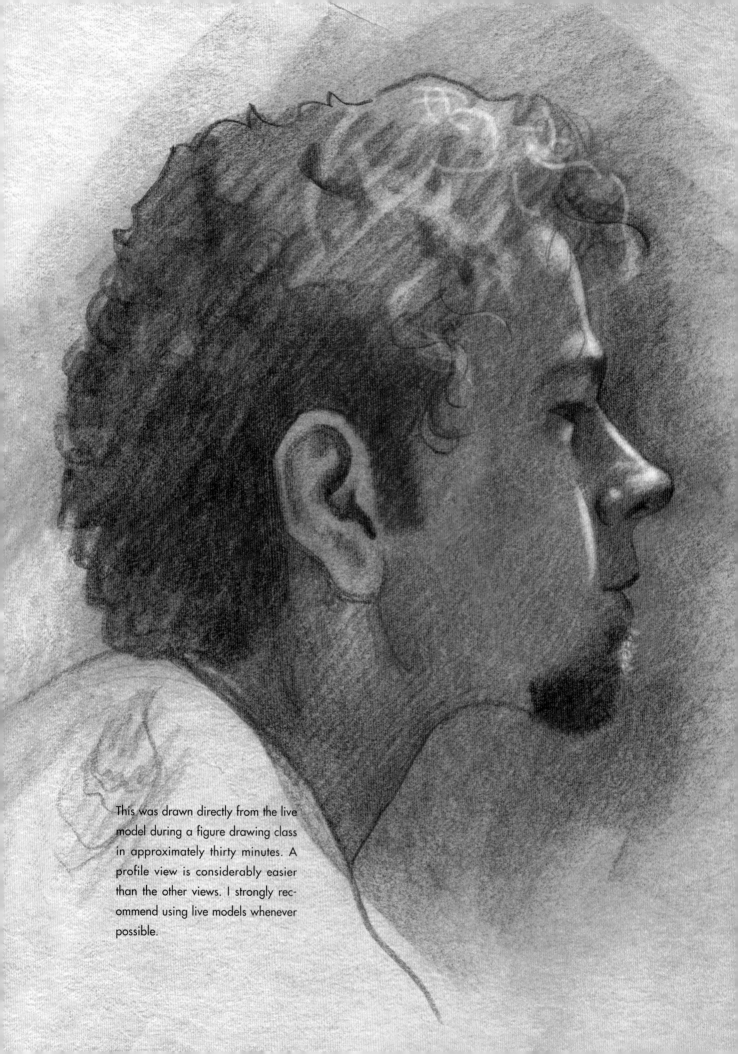

This was drawn directly from the live model during a figure drawing class in approximately thirty minutes. A profile view is considerably easier than the other views. I strongly recommend using live models whenever possible.

PORTRAITS

Nowhere is the importance of the shape more apparent than in the portrait. Caricaturists are very sensitive to the identifying shapes of a head. That's why a good caricature can be a more powerful likeness than a mechanically accurate copy of a photograph.

Words cannot adequately describe the process of drawing a good portrait. I can tell you how to go about getting an exact photographic approximation of a given head, but that's almost pointless, since it's much easier to trace a photograph. You could also arrive at the same result by drawing a grid over your photograph and transferring it to your paper.

You would think by now that we would be enlightened about the use of photographs in creating art, but there still is a stigma attached to it in some circles. My position is that photography is nothing more than another tool for the artist to work with. Like any other tool, if it's misused, it can backfire on you. The only important thing is the end results you get with your tools. Some artists use photographs brilliantly and get results that would not be possible any other way. Amateurs slavishly copy every little nuance without serious aesthetic consideration, and get predictable results. I am unable to even trace a photograph and get anything but horrible results. The only way I can work with photographs is to use them strictly for reference; if I study them too closely, I wind up with very mediocre results, and the photo is usually better than my drawing. My advice to you is to do the same: Use them only for reference. They can keep you from learning to draw.

Portraiture can be the most frustrating of all the arts, because we all perceive things differently. It's almost impossible to get everyone to agree on whether you have a good likeness or not. The best way to get an agreement from the person whom you're drawing is to make him or her look better than real life. I find that I'm almost never satisfied the next day when I'm trying to draw a portrait. It looks different to me every time I see it.

It takes a special combination of talents and abilities to produce good portraits consistently; very few artists are constituted for it. The concentration and discipline required are more than most of us are willing to put forth on a daily basis. If you are not positively driven by some inner urge to do so, you should probably stay away from trying for photorealistic attempts at portraiture. Unless you're satisfied with mediocrity, you will certainly wind up discouraged.

By all means, strive for the essence of the model you're drawing, and don't be satisfied with anything less; that is where true beauty lies. But don't look for a photographic likeness. There are a couple of examples of these disappointing attempts in this chapter, where I was too strongly influenced by the slick tones of the photograph, totally missing the deeper beauty of the sitter.

WORKING WITH PHOTOGRAPHS

Use a photo as though it were a living model. On the facing page is a drawing made from a photograph (below). This drawing was made by attempting to be as accurate as possible in getting the big shapes first, and placing the features second. The other illustration below shows the two major shapes simplified.

I carefully measured every important point before putting it down so that it matched the photo as exactly as I could. Frankly, I don't have the patience for this approach anymore. The big changes from the photo are in the final rendering. By leaving certain things out and emphasizing others, I believe I got the drawing to look a little more like the subject than the photograph does, but it still is disappointing. There is a world of difference between caricature drawings and academic-type renderings. This difference lies in the basic shapes. By exaggerating the shapes identifying characteristics, we can get a more powerful resemblance. The secret lies in the degree of exaggeration and ability to recognize these characteristics. You also need to know what to leave out in the rendering process.

 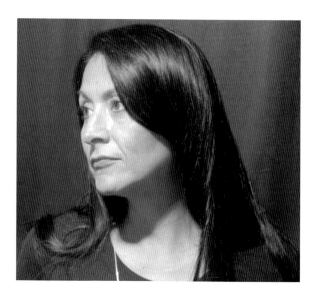

Facing Page: This is a drawing from a photograph of a fellow student in a life drawing workshop who graciously consented to pose. She has beautiful, classic facial planes, and the way her black hair frames her face is a perfect example of how shapes work. Her eyes are much darker than they show in the photograph, so I adjusted them accordingly, and made a few minor adjustments in the details. Still, this drawing does not capture the essence of the sitter.

I would have greatly preferred drawing her from life. The real beauty of a person lies in the building of character over a lifetime, and this is often missing in photographs. That's one reason why drawings from photographs are usually only pretty, not beautiful.

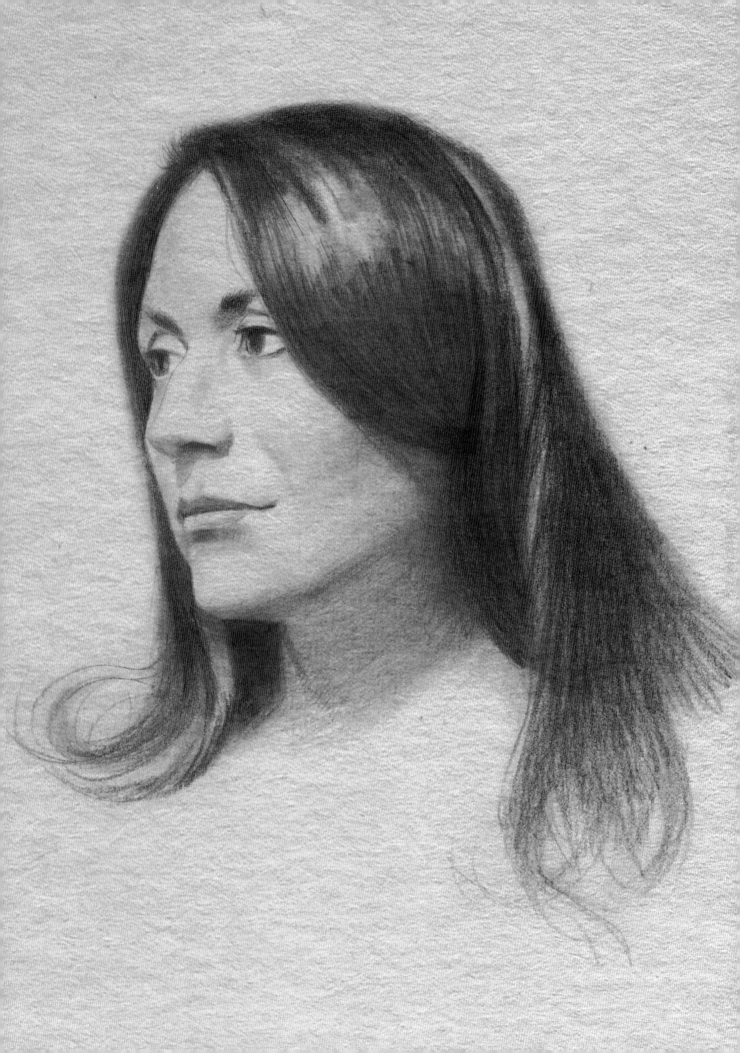

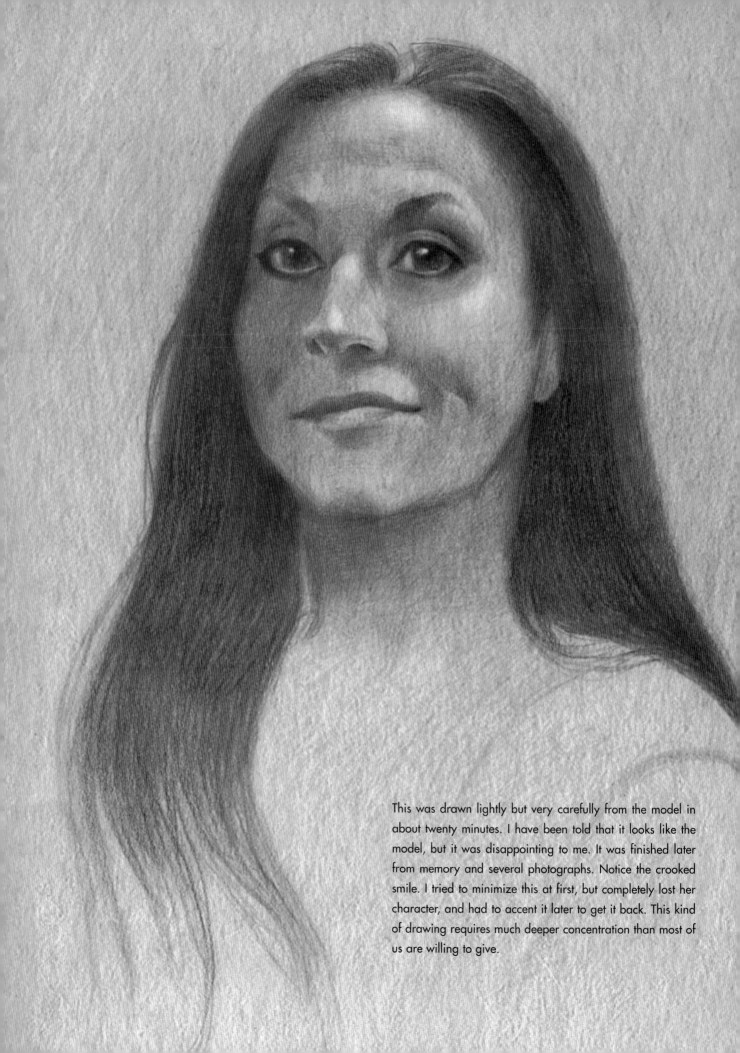

This was drawn lightly but very carefully from the model in about twenty minutes. I have been told that it looks like the model, but it was disappointing to me. It was finished later from memory and several photographs. Notice the crooked smile. I tried to minimize this at first, but completely lost her character, and had to accent it later to get it back. This kind of drawing requires much deeper concentration than most of us are willing to give.

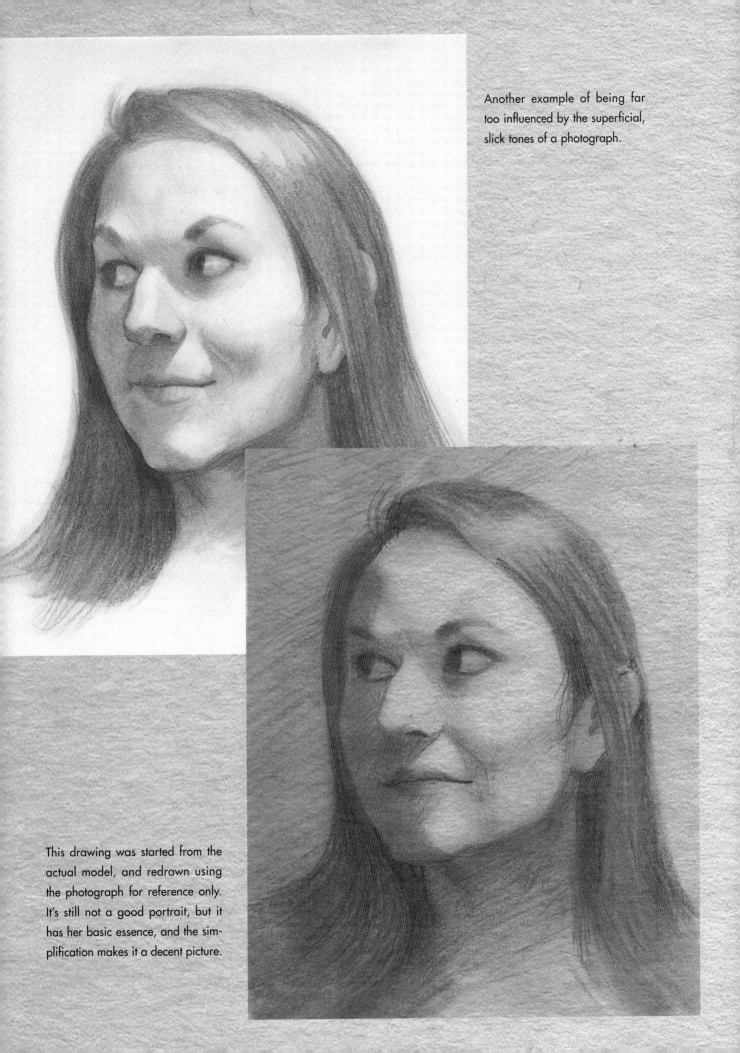

Another example of being far too influenced by the superficial, slick tones of a photograph.

This drawing was started from the actual model, and redrawn using the photograph for reference only. It's still not a good portrait, but it has her basic essence, and the simplification makes it a decent picture.

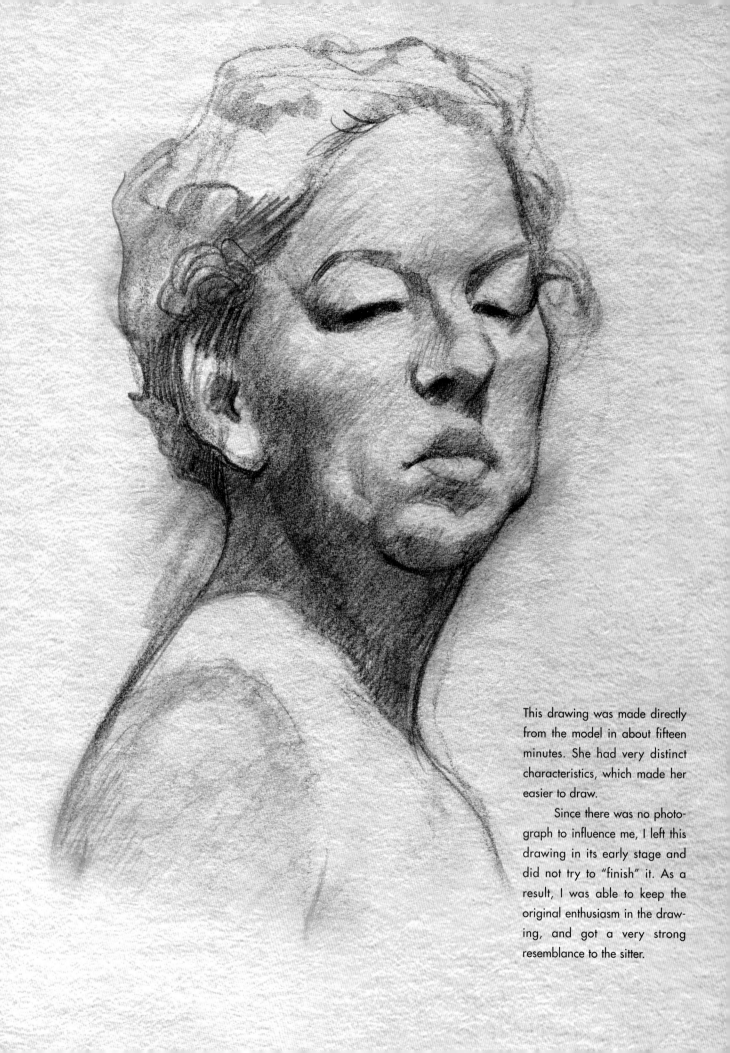

This drawing was made directly from the model in about fifteen minutes. She had very distinct characteristics, which made her easier to draw.

Since there was no photograph to influence me, I left this drawing in its early stage and did not try to "finish" it. As a result, I was able to keep the original enthusiasm in the drawing, and got a very strong resemblance to the sitter.

BEAUTY

believe that in order to get a really good portrait, you have to be able to see the beauty in every model. Learn to recognize real beauty. Almost every person I've ever met is beautiful in a special way. The years have a way of sculpting the features into ever more beautiful forms. Different races have their own beauty, and the differences should be treasured, not hidden.

It is unfortunate that Hollywood has narrowed our ideas of what constitutes true beauty. Children know instinctively how to look for it. When I was a child, I thought my grandparents were the most beautiful people on earth. It took Hollywood quite a few years to convince me otherwise. Fortunately, I've returned to my old way of looking at things, and I see beauty everywhere I look.

Cultures that are not exposed to our movies or other artificial influences have a very different idea of beauty than we do. Even our ideas of what constitutes the ideal weight for a person could be challenged.

Several years ago I saw a TV program about beauty that has stuck with me. Researchers gathered photographs of a huge cross section of faces of all types, male and female, of people from around the world. They then put these pictures into a computer and came up with what could be the "average" face. The results should not have been very surprising. The images the computer produced were of a perfect Hollywood-type star or starlet. If you think carefully about that, you'll be far more comfortable with yourself if you're one of the lucky people with character built into your face.

Older men and women are not only easier to draw because of this, but actually more beautiful. There is the whole story of a lifetime there for us to see if we are perceptive. The whole body carries this story, but the face is obviously the most visible.

When you become sensitive to these character-building factors, you will find that your ability to draw portraits shows a dramatic improvement.

The biggest obstacle to getting a strong likeness in a portrait is ego. Most of us are tempted to try to please the sitter by smoothing out the wrinkles, minimizing that big nose, or what you have. All that this does is average the sitter out and make him or her look like everyone else.

John Singer Sargent is considered by some as one of the best portrait painters of his time. I certainly agree that he was one of the finest painters of any time, but I think many of his portraits were done to flatter his rich clientele. As a result they lost the sitter's essence, and were not up to his standards as a painter.

Today we have painters like Alice Neel who exaggerate the "flaws" in their sitters and end up with powerful, if sometimes brutal, likenesses. It will be well worth your time to study her work if you can find it. I believe she is successful because she sees the real beauty in so-called flaws.

ONE, TWO, THREE

It's time to find out what you've learned up to this point. Although I'm not expecting a serious likeness in this demonstration, give it your best shot. When you work this way, by digging out the basic structure, a likeness often happens without conscious effort. It may not be a portrait, but if you approach it right, it will definitely suggest the model whether you intended it to or not.

Stay loose, but work slowly enough to get as close as you can. Look for the exact placement of things, then step back and examine your work after each step.

If you're not comfortable yet with drawing the basic head map, you need to keep working at it until you are, but you can try this exercise anyway. We are still not too concerned with perfection—yet.

I really don't think that photographs are the greatest thing to work from when you're learning; a live subject is infinitely better. But I have to be realistic. We're not going to have live models at our disposal every time we sit down to study. Do take advantage of every opportunity to work from real life, though.

You will notice that we are using a different approach again to start out. You will ultimately use a combination of all the approaches discussed here.

In this demonstration, I'm going to lead you through a fairly painstaking series of steps, and I want you to do your own drawing on a separate 8½-by-11-inch sheet of paper. Read the copy under each step first, and only draw after you clearly understand the logic behind the step. Then draw every line in the sequence shown.

I normally don't believe in leading you through things this exactingly, but there are good reasons for doing so at this point. In a short time you'll develop your own way of approaching your drawing, but this is the best way of demonstrating the thinking processes to use. You can waste too much time working things out for yourself otherwise.

Consider photograph 1 as your model. Set it up vertically a comfortable distance in front of you and work from it. Take a few minutes to study it, noticing where it resembles or deviates from our map, and trying to see the form of the skull underneath the surface. Look for the silhouette shape as we discussed. Burn its image into your mind.

Have you got a strong picture of the overall shape in your mind? If you have, you should be able to do the next few steps easily. You'll want to fill your sheet approximately the way I'm filling mine here.

First put a short line or mark where you want the chin to be. Normally I use a simple dot, but this chin area is wider than normal, so give it some width. Next, pull the line nearest the eye, the facial edge line (A) down to meet the chin line. Note the slight angle that the head takes, and establish that now.

Third, decide where you want the top of the head (B), and carefully put it in. Finally, pull the line (C) that establishes the width of the head down to the chin line.

Now take a good look at your drawing and be sure you got the proportions and head angle close to the proportions and head angle in the photograph. If you're not satisfied, get it right now, before you proceed.

Lightly put in the tone that makes up the whole eye socket, starting with the eye closest to the first facial line. This

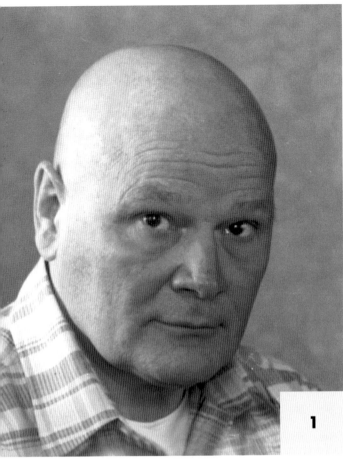

1

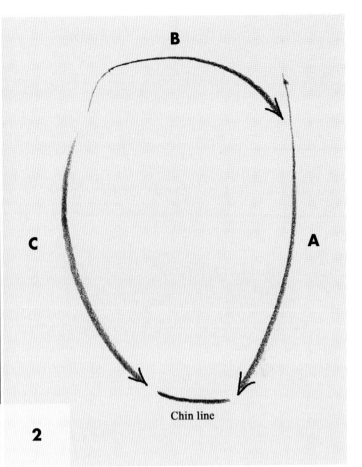

2

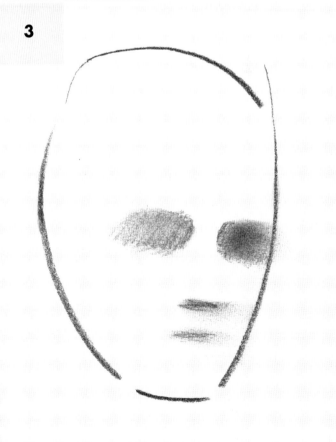

3

position is critical, so carefully check the photograph first, and remember what you learned about its position on our map. Start with the edge that touches the bridge of the nose, and work out to the facial line. Now put in the second eye socket, making sure you have the bridge of the nose the right width, and that this socket is in the proper position relative to the first one.

In other words, is it higher or lower? This establishes the tilt of the head.

Now put a smudge of tone under the base of the nose. Finally, put in the line for the mouth. Note that the mouth is slimmer than the one we used on our map, and is located somewhat above the halfway mark between the nose and the chin.

Take time out now to compare your drawing with the photograph. Now is the time to change things if you see any unintended differences between the photo and your drawing. Be sure that there are no obvious errors in proportion or placement before you proceed. If there are, change it or do it over.

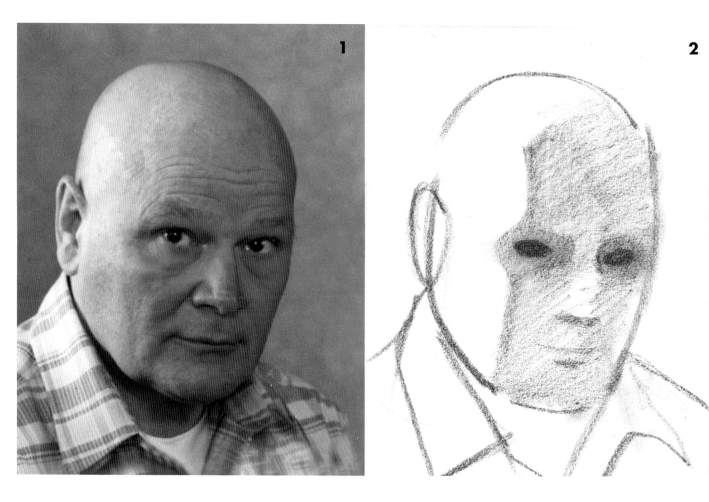

FINISHING UP

I f you were reasonably careful as you placed your lines, you have a properly proportioned map of the size you want, placed exactly where you wanted it. This completely eliminates the problems of getting a head out of size, at the wrong angle, or positioned wrong on your page or on the shoulders of a figure drawing. You simply note exactly where the chin sits on the figure you're drawing, and put it in first. Then you determine the exact angle of the head, and put that in. You next check the height of the head on the model if you're drawing a whole figure, and put a line where you need it on your drawing. Finally, you determine the width of the head, and put that line in.

If you've carefully considered them as you put them in, you've accomplished all this with three lines and a chin mark. There's still plenty of work to do, but remember this: Start right—finish right. Right?

I just told you to do it over if you weren't satisfied with your drawing . . . and that's exactly what I just did. I still didn't get enough width in the jawline on my original sketch, so I decided to change it now, rather than later. Usually I do these first lines so light that I can work over them easily, but I did this drawing stronger so we could reproduce it.

Now put in darker actual eye shapes about the size and position of the eyes in the lighter sockets. No details, just shapes.

Put in a soft, wide line with the flat of your crayon along the line that separates the light area from the dark facial area, and roughly fill in the front area with a light tone. Also loosely sketch in the shoulders and collar shapes. Actually, they should be put in as soon as possible to help in the visualization process.

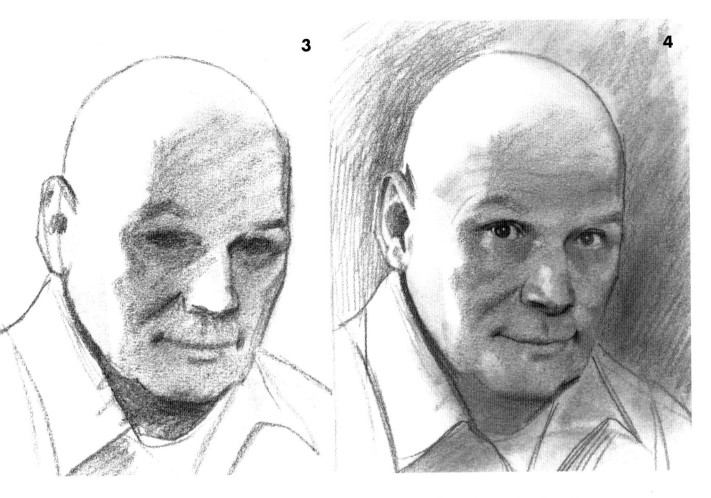

3

4

Work from the photograph, not my drawing, and do just a little more work on the mouth to get it positioned better. Add in a few more darks to get an even degree of finish over the whole head.

Now step back from your drawing and, without looking at the photograph, study it to see if anything bothers you about it. Change it, if possible, until you're happy with it.

Step back from it again, and this time very carefully compare it with the photograph as well as drawing 3. Where does it differ?

I just checked mine against the photo, and, although I wasn't attempting an exact copy, as things turn out it is almost exact. This doesn't often happen, and it really doesn't mean much at this point, but when I finish, it will probably have more resemblance to the photo than I'd really expected. This drawing is a good example of the fact that the structure carries the likeness. The fine details are only sugarcoating.

Don't worry if your drawing doesn't qualify as a portrait; we certainly didn't expect that at this point. But does it have the general character of the model?

Using an eraser to lighten a few tones here and there, along with the sharpened point of your crayon, try sharpening up the details of your drawing. Study the photograph for information on the features, but use your intuition about how strongly to emphasize things. Take it as far as you can, but don't try to go much beyond what I've done. If you feel the need, you might want to smear a tone here and there with your thumb or finger to blend it in better, but don't overdo it. Notice how a slight darkening of a value seems to turn a form into the paper—that is, to make it go back in space. Also, a slight lightening with your eraser brings it forward. Be careful with things like highlights, you can easily get them too strong, and they'll jump out at you.

RESULTS

If you're disappointed in your results from this exercise, don't be too concerned. Practically nobody can get the arrangement of lines and shapes "portrait perfect" without actually measuring things in some way. Mine was a fluke. But you should have caught the basic character. If you didn't, it's likely that that you need more work technically or—more correctly—manually. You haven't worked enough to get control of your hand and your drawing instrument. You need to know that your hand will do exactly what your brain tells it to. Devise a few concrete exercises where you are forced to put lines down exactly where you want them. My favorite is to scatter a few dots on a sheet of paper, then pull long, smooth, curving and straight lines down to meet them, trying to hit them cleanly every time. Another is to draw perfect squares and rectangles of different sizes, and then draw circles or ellipses inside them touching all four sides. You need to do these exercises quickly and confidently. Eventually you'll get them right every time. Then try this demonstration again, and notice the improvement.

It's also possible that you have perception problems. This can be anything from annoying to serious. We all have problems with our perception at times, and we simply ignore them and start over, or change things to get them right. Most artists struggle constantly to keep things from going askew; that's normal. Sometimes the solution is a simple matter of looking squarely at your paper as you work. Most

often, it's a matter of training yourself to see and compare things properly. In fact, that skill can take a great deal of effort for some of us, and if you make it a point to consciously think in comparative terms as you look at things, your ability to see properly for drawing will automatically get better surprisingly quickly. Also make it a point to compare sizes, shapes, spaces, colors, values, and edges on things even when you aren't drawing them.

Is the corner of the eye exactly vertically situated above the corner of the mouth? Does the edge of the face touch the tip of the nose in this view, or does it protrude beyond? How big is the forehead compared to the rest of the face? What angle would you use to draw in the face line? These are only a fraction of the things you need to train yourself to notice as you draw. Get in the habit of comparing things with other things. Learn to see geometric shapes where they might fit into things. For instance, you might see an equilateral triangle between the two irises in the eyes, and the tip of the nose in the front view of a face. Noticing it helps you draw it more accurately. Look for things that line up. The possibilities are endless.

On page 108, you will find out how to measure things while blocking in a portrait. This is nothing more than holding a pencil or brush out at arm's length, and—with your thumb or finger acting as a point of reference—comparing spaces, distances, or lengths of lines. You also check for things that line up with each other, as well as their angles against a vertical direction with the pencil. The trick is to always hold the pencil exactly the same distance from your eye, usually at arm's length.

It's probably a good idea to learn how to use this method, but I must admit, it bores me to death. Ultimately you can work out a system of actually measuring only one or two critical things, then let your eye take over from there.

THE ELUSIVE CONTOUR

It seems that the English language—and certainly my command of it—is not sufficient to clearly capture my thoughts on one of the toughest questions ever put to me: "How do you know where to put those lines?"

I have attempted to answer in three books, and I'm still not convinced that I got it right, so here I go again. This time I'm not going to fall into the trap of trying to explain the unexplainable—that slippery subject of artistic expression. I'll leave that to some other brave soul. I'll simply tell you what little I do know about how to put something down exactly as it looks to your eye. You can supply the artistic part if it's in you.

First off, I do not believe that the human brain is designed to register images in a way that makes it possible to draw them with cold photographic accuracy. Even if it could, the camera has made that ability practically useless.

To clarify exactly what I'm talking about, I want you to get a pad of tracing paper and lay a sheet over a picture of a head that you'd like to draw. Now trace the outline of the head—outline only, no features. This is the contour, exactly the way the camera sees it. Pretty unimpressive, isn't it? That's what I'm talking about here.

I have never known, nor do I expect to meet, an artist who could draw a simple organic shape, like the human head, so accurately that it could be traced and still fit the model accurately. Even if it were possible, it would not have that spark of life in it. Most intelligent artists eventually come to realize this and look for something beyond photographic accuracy in their work.

When this kind of accuracy is necessary, such as in certain types of illustration, they logically look to the camera for help. By doing so, they avoid frustration and save a great deal of time. The whole trick in using the camera is to take only the most basic information from it. That's a skill in itself. To prove this, finish tracing all the details you need, then trace it onto a sheet of drawing paper and finish the drawing. Make it as good as you can. Unless you're an exceptional artist, when you honestly compare your drawing to the photograph the next day, you'll be horribly disappointed. The photograph will look much better. You get something indefinable when you draw rather than copy, even if you try to draw exactly what you see. There is great value in struggling to get things exact; somehow your personal interpretation of things still manages to get in even while you're trying to

be logical. Forcing yourself to compare things accurately by eye alone is the only way to improve your ability to see things properly and draw them as they really look.

To me, measuring, or any other mechanical way of laying out a drawing, takes the fun out of it. I do it occasionally to check an alignment if necessary, but avoid it when I can. I'm sure that I never learned to do it properly because it makes so little sense to me. I strongly recommend you avoid it as much as possible, too, after you've trained your eye to the point that you can trust it to take you where you want to go.

When you draw an object that is solid onto a flat sheet of paper, you begin a process that, by its very nature, becomes more intuitive than mechanical. You could subdue the intuitive part by relying only on mechanical measurement, and come very close to getting things mechanically accurate every time. But why would you want to? The process of measuring is very time consuming, and never perfect anyway. After all that boring work, you would end up with what looks like everyone else's drawing.

The more you encourage the intuitive part of the equation by using it, the better it gets, and the more of your own unique viewpoint of things gets into your work. Isn't that what art is all about? After all that, I will show you what little I know about measuring on the next page. There will be times when you have no choice but to use it.

MEASURING

If you sketch things in lightly at first, and then check them by measuring, it will be easier, and you will also be giving your own intuitive powers a boost. Here are the basic things you look for when you measure.

You first need to establish the size and angle of the head. You do this by straightening out the segments of the contour into the longest lines possible. Then measure the short dimension (the width) first, using it to get the others right. In other words, how many widths go into a length, and so on. Check the angles by holding the pencil along the line on the model, and comparing it to the true vertical. There is always something vertical nearby to check it against. You also do this to see how things line up with each other.

Now simply refine the big block by carefully studying the edge or contour lines. Much of this step can be accomplished by eye, but you need to be extremely careful to make comparisons to all the surrounding angles and lengths of line as you put new lines in. You're still working with straightened lines in this step.

You now find the center of your subject—in this case just over and slightly behind the eye.

The center gives you another reference point for the placement of all the other features using smaller and smaller units for measurement, which are carefully checked against the existing contour, as well as each other. This step is as far as you should ever go if you're tracing a photograph or using a projector. You might roughly put in the shadow edge, and block in a tone for the shadow area. Note that this detail-free layout has the special character of the finished head already. You're now ready to finish up by eye alone.

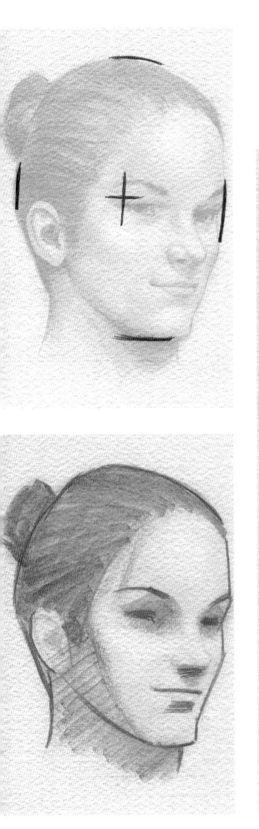

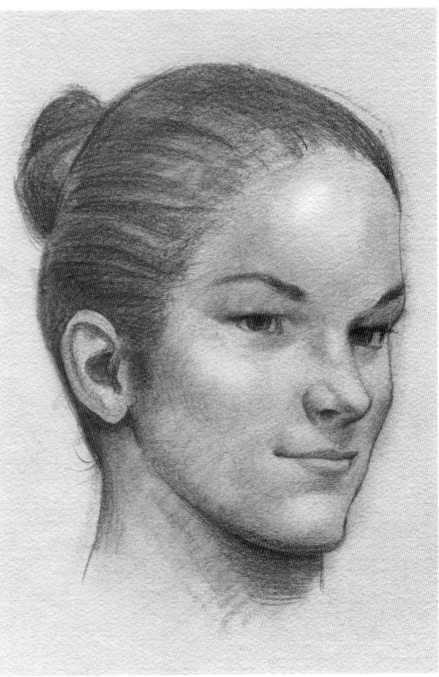

A LAST REVIEW

If only learning things were as quick and easy as reading about them, you could now put this book aside and move on to something else. This may be true for a precious few, but for most of us, reading about things is just the starting point. Fortunately, if you are meant to be an artist, the process of learning to draw should be absorbing and pleasurable. The hours fly by when you get deeply into it. It can also be frustrating and discouraging when the natural quirkiness of our visual process gets in our way. Let's take time now to go over the things we've covered to see just what you've learned.

In the basics, you learned how the head is proportioned, and where the features fit into an average head viewed from the front. You also should have been drawing steadily and freely with the proper grip on the crayon to improve your manual skills.

Things got more complex as we got to the different view angles. You were now required to begin to see the structural aspects of the head, and to visualize it at differing angles. All this time you were minimizing the importance of the individual features. If you got things right, you should have been drawing free, strongly constructed, solid head shapes when you left this chapter.

The anatomical information came next. This was kept to a bare minimum to keep your brain from getting full of technical stuff that an artist with a good pair of eyes probably doesn't need anyway. Remember, there is no shortage of good books on anatomy if you really want more of that kind of information.

In chapter 4 you learned about the essence of an individual head and face—how you look for it, exaggerate it, and get more than a likeness in your drawings. It would be a good idea to keep a small sketchbook with you at all times to be looking for the shapes in people that make up their essence.

Then, in chapter 5, we had a look at symbolism and how it relates to "modern" ideas about expression, which turn out to be as old as art itself.

In chapter 6, you learned about values, and how to use them to make your drawings look solid and believable. The important lesson here was to simplify the number of values in your work to get a clearer separation between them. Too many of us have a tendency to smear the values together into a mush that is neither one or the other, just a kind of dull, boring, nondescript gray. We also tend to put overly dark tones into the light areas, breaking up the beautiful, logical separation of the light and shadow areas.

In chapter 7, on portraits, you found that it's reasonably easy to come up with a mediocre portrait, but hard to do a good one, and not all of us are suited for it. You also learned that when you think of the essence, instead of simply trying to copy a photograph or person, you'll often get a better likeness.

FINAL THOUGHTS

If there's one thing I've learned in the writing of three books about drawing, it's that there are just about as many ways to do things as there are people doing them. So keep an open mind. If you made an honest attempt at doing something, and you still feel that you can do it better another way, do it the way that gets the results you want. Explaining something is a lot harder than doing it. If everybody thought the same, it might be easier, but we all bring our own accumulations of experiences and egos to the table, and that complicates matters.

The big thing that I want to leave with you is this. Drawing seems difficult for most people because you see three-dimensional objects, but draw them in two dimensions. At some point in the process of drawing, you make that transformation in your brain. If you try to draw an object on the flat surface while your mind is still thinking three dimensionally, you get confusion. Your drawing will pick up all kinds of distortion. Most teachers today preach about "seeing the form" while you draw. I believe that this can be the biggest single obstacle that a student has to overcome to learn to draw. Simply changing the mantra to "seeing the shape" would alleviate the problem.

Look for the big shapes that impress you, get them down first, and relate everything else to them. That's the secret. If that shape happens to be the nose, or anything else, it doesn't matter. If it's hard to draw the shape, look at the line that surrounds it, put down the easiest of its segments first, then finish the shape.

We have approached the drawing of heads in a logical way in this book. We started out with the big, simple proportions, and moved into progressively more difficult areas at a pace that you should have been comfortable with. If you followed each chapter in sequence, and actually did the drawings as you went along, you will have come a long way. If you just skimmed through the book, I hope you enjoyed it. In either case, if you are a serious student of drawing, a lifetime of fascinating and pleasurable study awaits you when you draw people.

INDEX